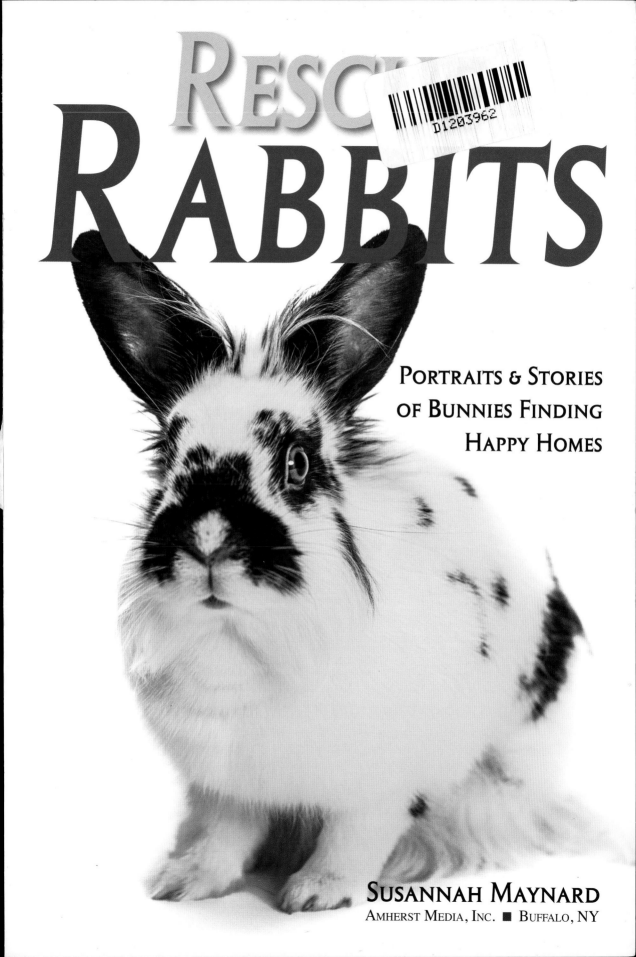

RESCUE
RABBITS

PORTRAITS & STORIES OF BUNNIES FINDING HAPPY HOMES

SUSANNAH MAYNARD

AMHERST MEDIA, INC. ■ BUFFALO, NY

DEDICATION

This book is dedicated to all the rescues and hard-working volunteers I worked with for images for this book. You are dedicated to what you do in making sure that bunnies are given the opportunity to find their happy endings. I would like to extend a special thank you to Sue and Keith Zimmerman of Buckeye House Rabbit Society, who are not only dedicated rabbit rescuers, but were so kind as to extend to me and my scruffy companion, Mr. Bojangles, the hospitality of their home.

Published by:
Amherst Media, Inc.
PO Box 538
Buffalo, NY 14213
www.AmherstMedia.com

Publisher: Craig Alesse
Senior Editor/Production Manager: Michelle Perkins
Editors: Barbara A. Lynch-Johnt, Beth Alesse
Acquisitions Editor: Harvey Goldstein
Associate Publisher: Katie Kiss
Editorial Assistance from: Carey A. Miller, Roy Bakos, Jen Sexton-Riley, Rebecca Rudell
Business Manager: Sarah Loder
Marketing Associate: Tonya Flickinger

ISBN-13: 978-1-68203-374-6
Library of Congress Control Number: 2018936011
Printed in the United States of America
10 9 8 7 6 5 4 3 2 1

www.facebook.com/AmherstMediaInc
www.youtube.com/AmherstMedia
www.twitter.com/AmherstMedia
www.instagram.com/amherstmediaphotobooks

CONTENTS

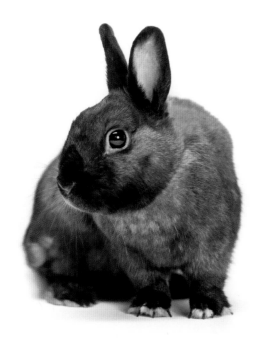

ABOUT THE AUTHOR

Susannah Maynard is a lifelong animal lover, animal rescue advocate, and pet photographer. Long before she picked up her first camera, her mother's childhood Kodak Brownie, she captured images of the world around her with a pad of paper and a box of crayons. Her creativity and love of animals was instilled in her at a young age by her mother. Growing up in a house full of cats, she never lacked for subjects for both her drawing and photography.

After trying a variety of careers, from fundraising to publishing, Susannah was at a career crossroads when, in 2011, she adopted her heart dog, Mr. Bojangles, and discovered there was such a profession as pet photographer. Deciding to turn her love of both

photography and pets into a career, Pet Love Photography was born.

Susannah has spent the last several years honing her skills as a pet photographer by photographing hundreds of rescue and client pets. She primarily works on location to make sure that her pet subjects are as comfortable as possible in environments that are familiar to them. Susannah is a member of Professional Photographers of America and HeARTs Speak.

When not out photographing other people's pets or donating her time to rescue organizations or other pet charities, Susannah spends time with her own rescue pet family: her dogs Stella, Mr. Bojangles, and Paco, and her cat, Diana.

Photo © Jason Kenney

INTRODUCTION

Rabbits, bunnies, hares—whatever you may call them—are the third most surrendered animal in shelters in the Unites States. An influx of rabbits arrive in shelters and rescues every year in the months immediately following Easter, when people realize that the "Easter bunny" they bought requires a lot of care and attention. Another reason why many rabbits end up in shelters is that they are not altered, and unaltered rabbits produce more rabbits—quickly—as their gestational period is only 30 days (hence the phrase "breed like rabbits"). Many times, people do not spay or neuter their rabbits because these surgeries are often more expensive than the same surgeries for dogs and cats, and there are fewer vets experienced in performing the surgeries on bunnies.

While writing this book, I learned a lot about rabbits. One surprising fact is that there are far fewer rescues that take in rabbits than do cats and dogs. In fact, I had to travel around Ohio to photograph enough rabbits for this book. That being said, there are many wonderful rabbit rescues around the country, many of them affiliated with the House Rabbit Society, a non-profit organization dedicated to rescuing abandoned rabbits, finding them permanent homes, and educating the public on rabbits and rabbit care.

Certainly, some rabbits are surrendered to rescues or shelters, but many are abandoned in the wild. Some folks think domestic rabbits can survive in the wild. The truth is, some may survive for a while, but eventually, they will be subject to the same predations as wild rabbits. The average lifespan of domestic rabbits is ten years, while the average lifespan of a wild rabbit is generally less than three years.

Most of the bunnies that appear in this book were photographed through my work with rescues around Ohio and Northern Kentucky. Some were already adopted into their forever homes, but many were—and are—still looking for a forever home. The majority of the adoptable bunnies live in foster care, but whether they live in foster care or in a rescue facility, they all need one thing: a permanent, loving home. If you have never cared for a pet rabbit before, but are inspired to adopt one after reading this book (and I hope you will be), please read as much about rabbits as possible, because they require different care and handling than do cats and dogs. A great place to start is with the House Rabbit Society website, rabbit.org.

As part of my ongoing efforts to give back to the rescue community, I will donate a portion of the proceeds from the sale of this book to the following rabbit rescue organizations: Buckeye House Rabbit Society; Pampered Pets Animal Rescue in Cincinnati; Ohio House Rabbit Rescue in Columbus; and F5RS in Youngstown, Ohio. All of these organizations welcomed me into their homes and facilities to photograph their rabbits, and this book wouldn't have been possible without them.

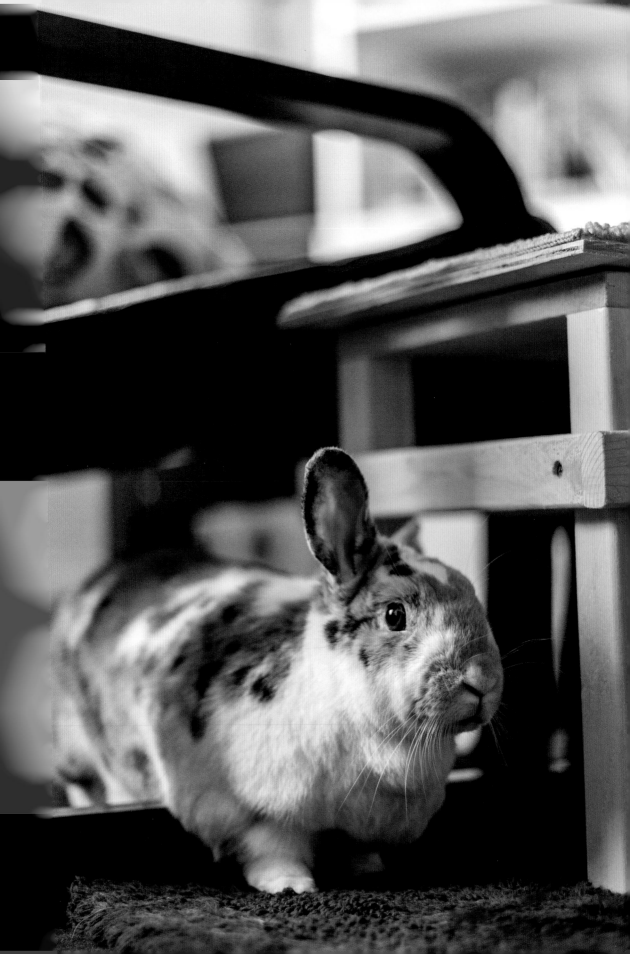

ADULT RABBITS

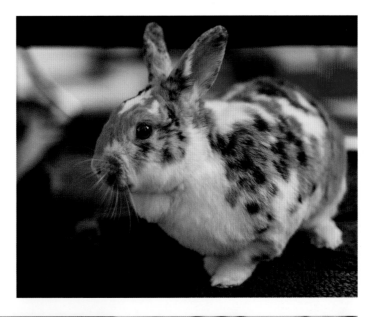

Lulu

Lulu is a house rabbit who lives the high life in her adoptive home. She is free to roam the second floor of the house and likes to hang out with her dad in his home office. Lulu was adopted from a Northern Kentucky small animal rescue.

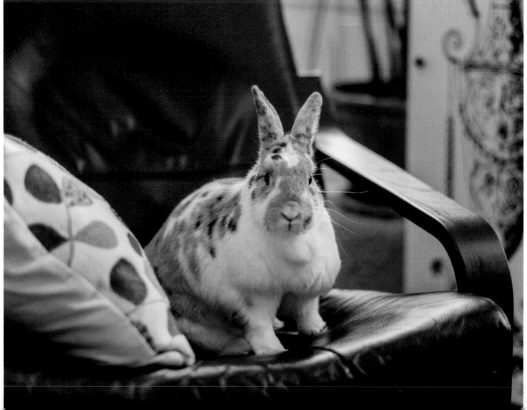

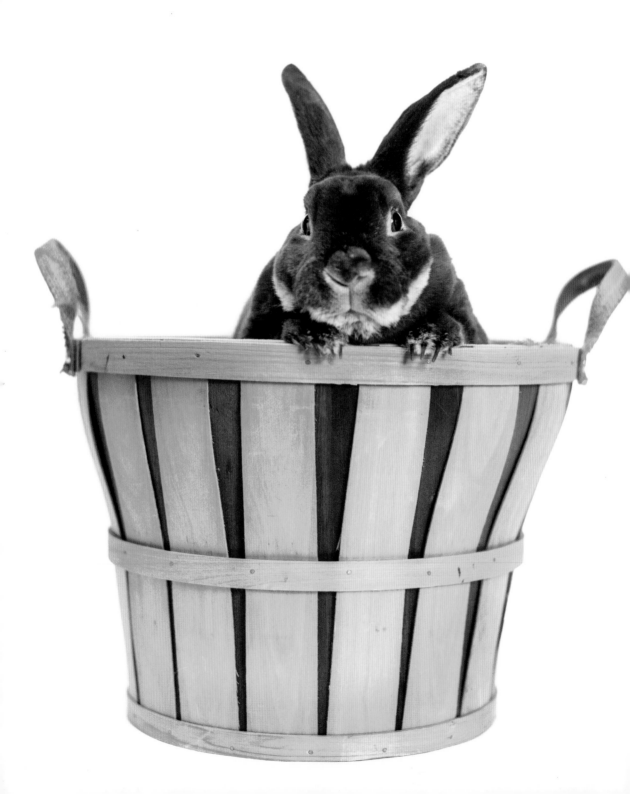

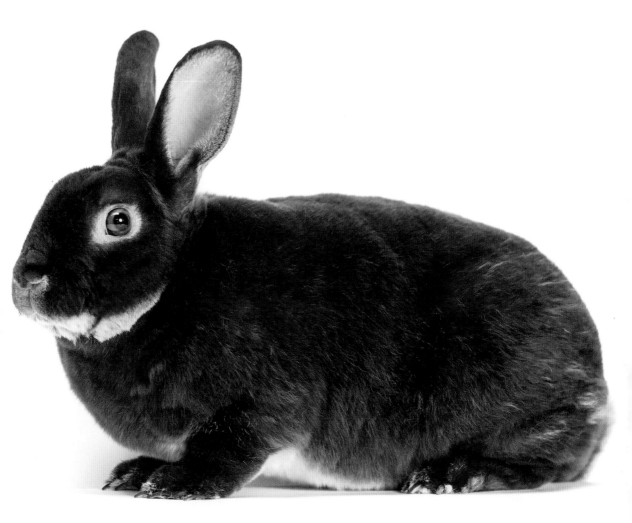

Mason

(*previous page and above*) Mason is a gorgeous, young Rex rabbit who ended up with a rescue in Columbus, Ohio. Rex rabbits are known for their velvet-like fur and are extremely soft to the touch. Lucky Mason is now loving life in his adoptive home.

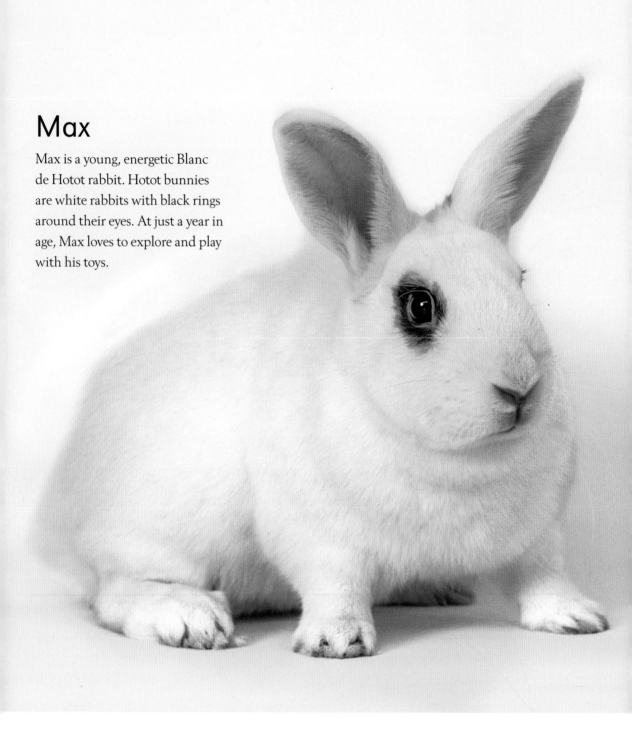

Max

Max is a young, energetic Blanc
de Hotot rabbit. Hotot bunnies
are white rabbits with black rings
around their eyes. At just a year in
age, Max loves to explore and play
with his toys.

Naomi

Naomi was found as a stray, along with her litter of babies, in Parma, Ohio. Wary of people, she was caught using a net. Once safe, it was discovered that she had an abscess on her abdomen and was covered in ticks. Nursed back to health, Naomi is now 100 percent healthy. She loves to have her head petted and enjoys snuggling with her stuffed teddy bear. This sweet girl was adopted and is now named Lulu. She lives with her family and her bunny mate, Leo.

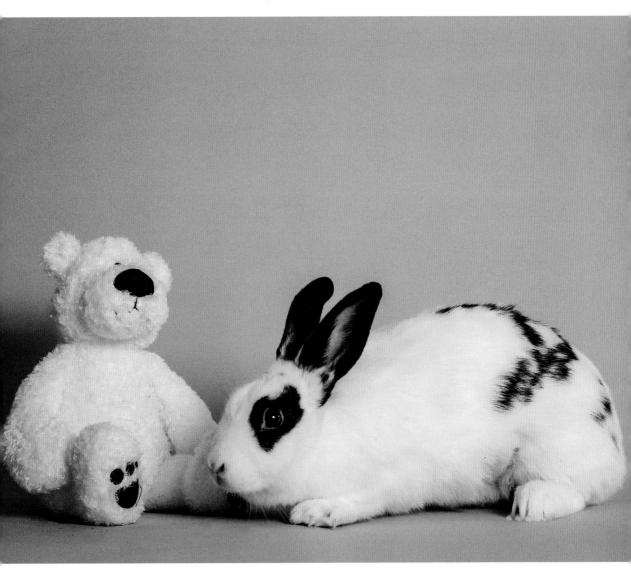

Cyndi

(below and following page) Cyndi is a beautiful Mini Rex with a sleek, plush black coat. She is a shy, young bunny and loves her stuffed duck and other toys. She came to rescue at six weeks of age with her mom and siblings when they were seized by animal control after their owners moved away and left them. Now around three years old, she is a young adult and looking for a home of her own. She is a neat rabbit and likes to stay clean. Mini Rex rabbits are known for their distinctive coats of thick, soft fur.

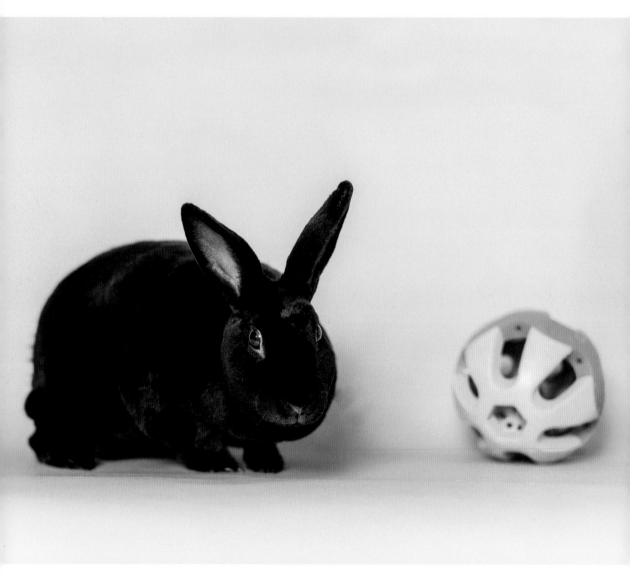

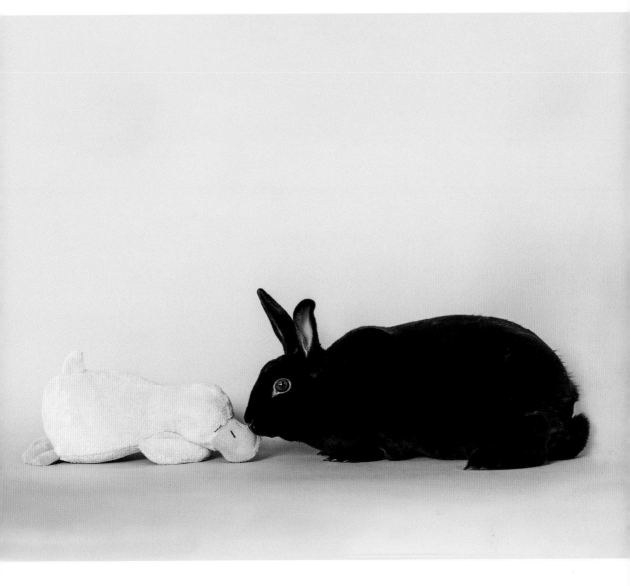

"MINI REX RABBITS ARE KNOWN
FOR THEIR DISTINCTIVE COATS
OF THICK, SOFT FUR."

Columbus

Columbus is a young male Lionhead rabbit who loves to seek out new adventures. He was brought into rescue with several other rabbits when their owner could no longer care for them. This adorable rabbit was quickly adopted to a loving new family.

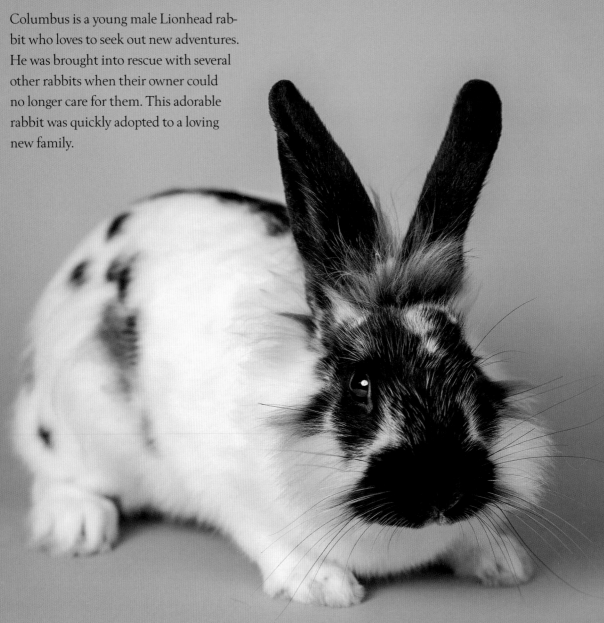

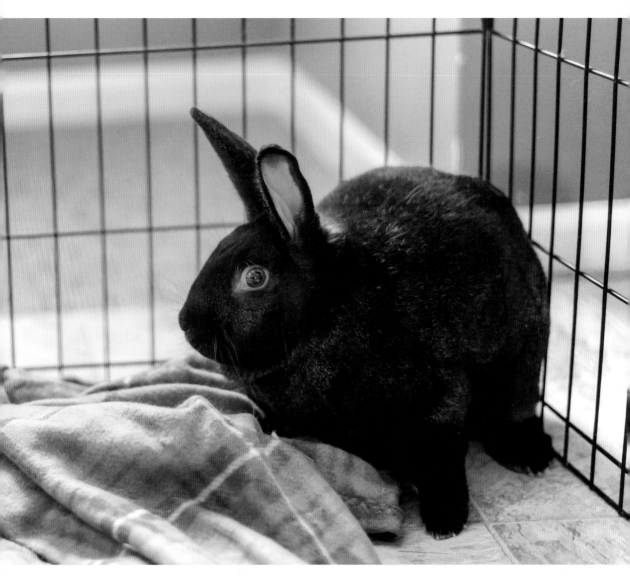

Neil

Neil has been with his rescue for over a year. He can be a little
timid and is startled by sudden sounds or movements, so he
needs a quiet home where he can feel comfortable and safe.
Sometimes it takes bunnies a little longer to come out of
their shells.

Cupid

Cupid is a Continental-mix rabbit. He, along with several siblings, was rescued right before Christmas, and all were given reindeer names, as there were eight total. Cupid and his siblings were rescued by a Good Samaritan who discovered that the campground petting zoo where they lived was going to sell them back to the person they were originally obtained from, so he could kill them for meat. Cupid, though the smallest of his litter, is still a big boy.

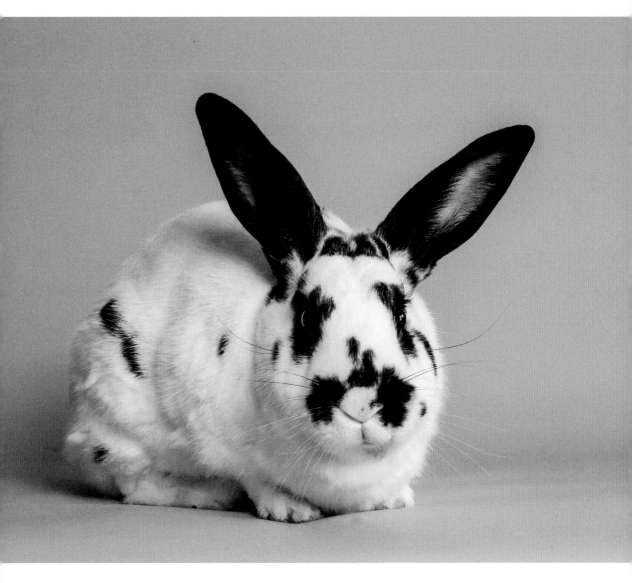

Oscar

Oscar is so named, not because he's a grouch, but because he was found in a garbage can! He was rescued by a Good Samaritan and brought into rescue. Oscar is a little reserved around new people, but once you offer him a treat, he is your best friend! He really enjoys food and loves to cuddle.

Gabriella

Gabriella is a sweet, petite rabbit. She is very friendly once she gets to know you. This English Spot mix was found as a stray in Northern Ohio with her brother, Aaron. Gabriella is now happy in her forever home.

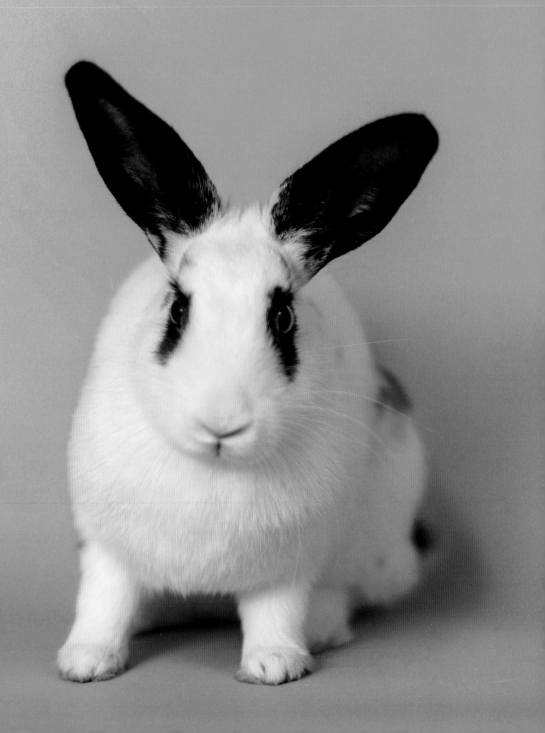

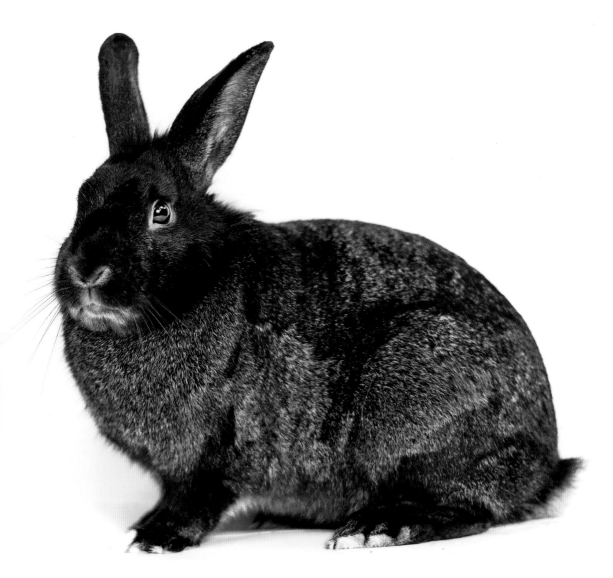

Little Bit

Little Bit is a female rabbit of unknown age. She is a Lion-head mix, although after she was brought into rescue, a lot of the whispy hairs that are characteristic of a Lionhead disappeared. She was rescued, along with a number of other rabbits, from a hoarding situation. Little Bit was looking for a quiet home without any young children—and she was lucky enough to find it!

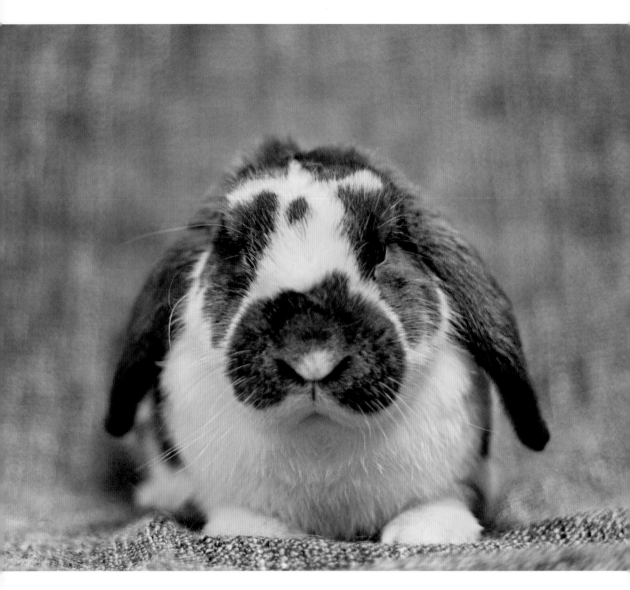

"Lop-Eared rabbits require special attention to their ears, as they are prone to injuries and infection."

Darby

(previous page and below) Darby, a young Mini Lop, was put up on Cragislist and came with a cage. Someone bought Darby, but only wanted the cage, so they put the cage in their garage and dumped Darby in the yard. A Good Samaritan neighbor contacted an organization that rescued Darby. Lop-Eared rabbits require special attention to their ears, as they are prone to injuries and infection. Proper care is essential.

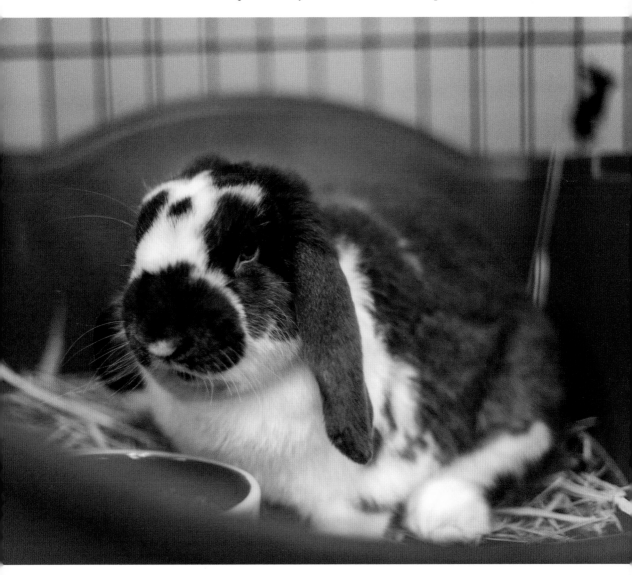

Alexis

Alexis is a gorgeous black female New Zealand mix who was surrendered to a local animal shelter and became depressed. Fortunately, she was taken in by a rescue. She lives in a foster home now and is much happier. According to her foster, she is very interested in having a rabbit friend, so would be a good candidate for a male looking for a partner. While happy in her foster home, Alexis would be happiest in a home of her own.

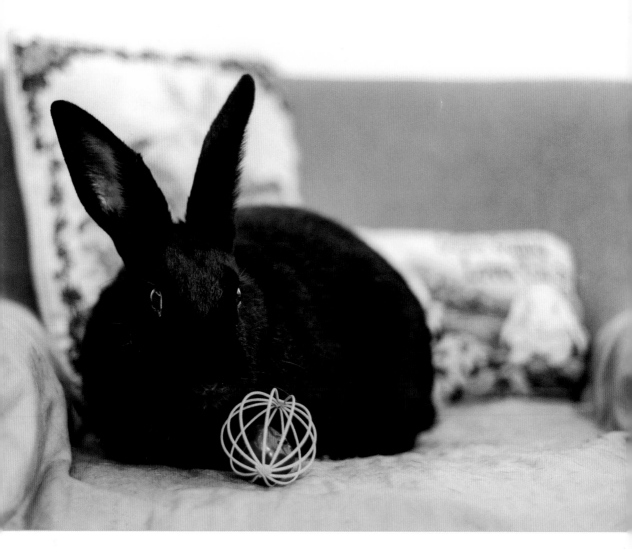

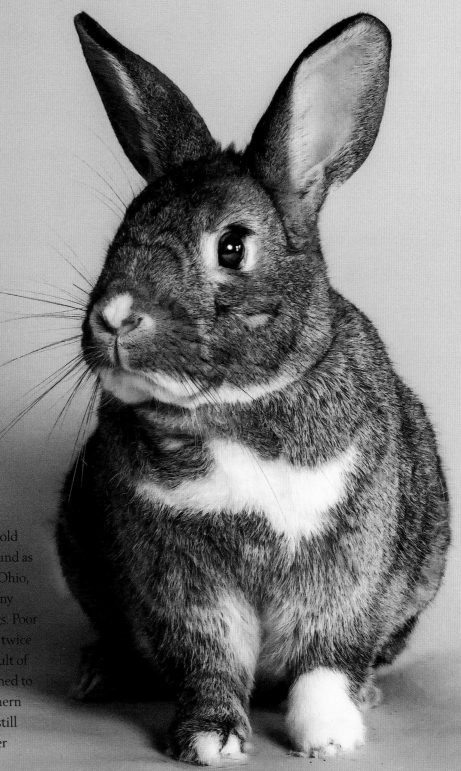

Barry

Barry is a two-year-old
bunny who was found as
a stray in Medina, Ohio,
along with his bunny
parents and siblings. Poor
Barry was adopted twice
but, through no fault of
his own, was returned to
his rescue in Northern
Ohio, where he is still
looking for a forever
home.

Aaron

(*above and following page*) Aaron is a young bunny under a year old. He was found as a stray in a park along with his sister. He has been adopted and is now known as Jasper. He lives with his bunny friend, Clementine, and some kitty friends, as well.

"HE LIVES WITH HIS BUNNY FRIEND, CLEMENTINE, AND SOME KITTY FRIENDS, AS WELL."

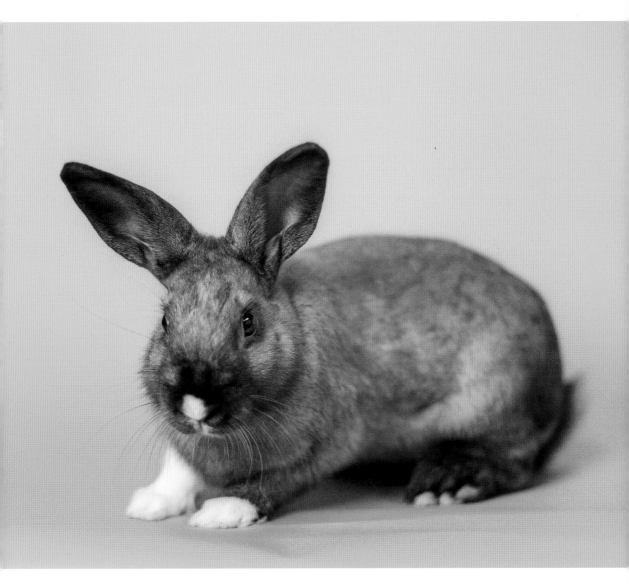

Blake

Blake is a big boy who is about two years old. He was surrendered to a shelter when his owner's landlord said Blake had to go. This calm, sweet boy was very unhappy in the shelter environment and was taken in by a rescue, where he lived and thrived in foster care until finding his forever home. He was adopted into a family that had previously adopted his new companion from the same rescue.

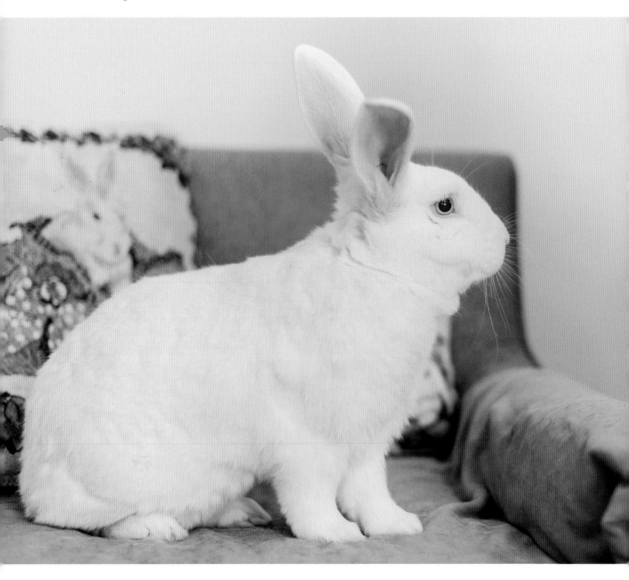

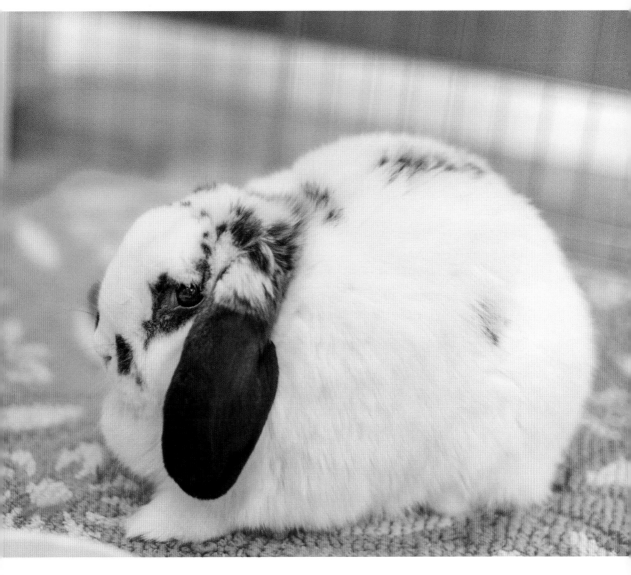

Bella

The adorable Lop-Eared bunny, Bella, is a sweet girl who, while lucky enough to end up in a Central Ohio rescue, was sad that it took a while to find her forever home. She is very sociable and enjoyed "conversations" with her rescue neighbor, Archie. Fortunately, Bella was adopted into a quiet and loving home after spending over two years waiting.

Bootsy

Bootsy is a fluffy, young, male Angora rabbit. He was surrendered to animal control and subsequently taken into a rescue. He is a sweet and patient bunny who loves his grooming sessions. Angora rabbits require extra grooming to keep their fur neat and free of mats.

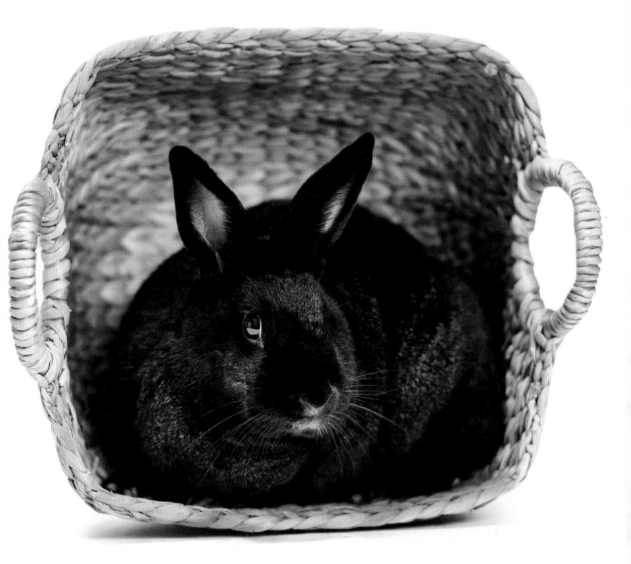

Kenya

Kenya is a shy mixed-breed rabbit who loves to run and play. She enjoys quietly exploring, as do many curious house rabbits. She ended up in a Central Ohio rabbit rescue prior to being adopted.

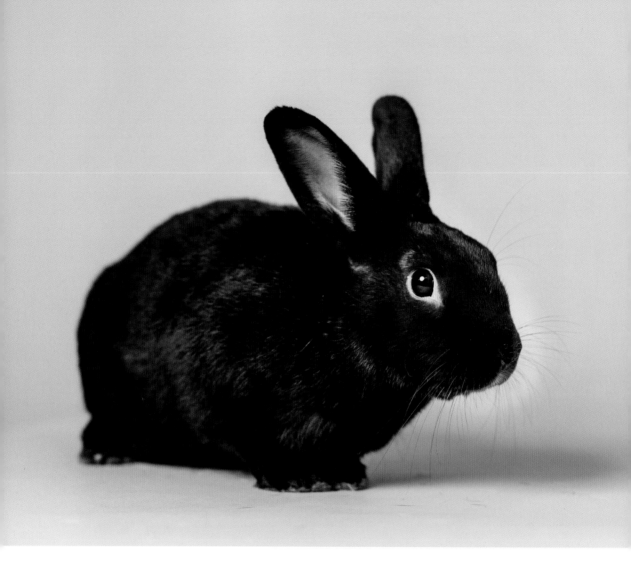

Clover

(above and following page) Clover is an energetic, male mixed-breed rabbit. He loves to stay busy by running around and playing with toys. Clover spent over a year in rescue before he was adopted into a home that understands his energetic nature and need for plenty of playtime.

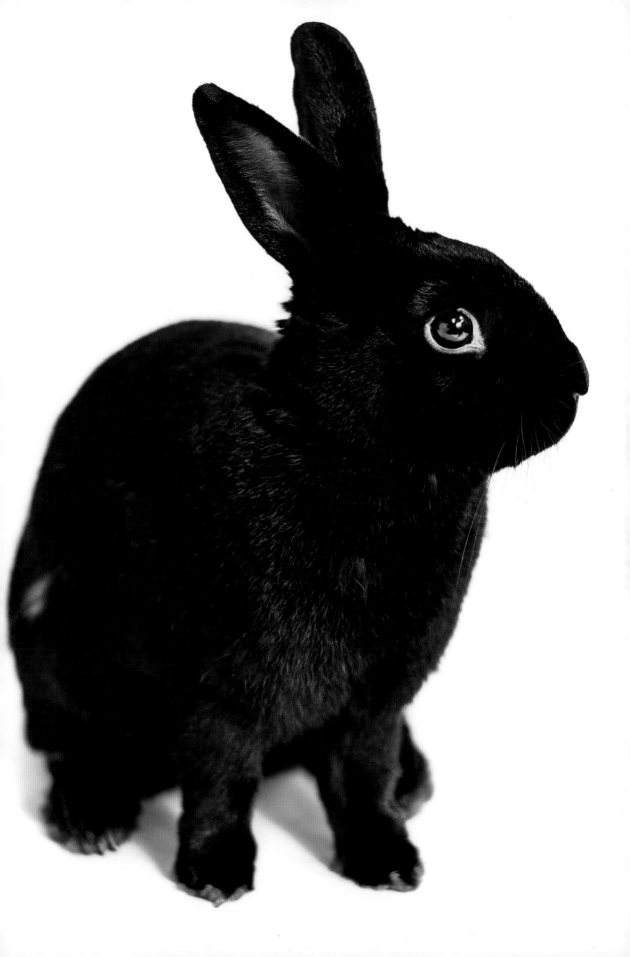

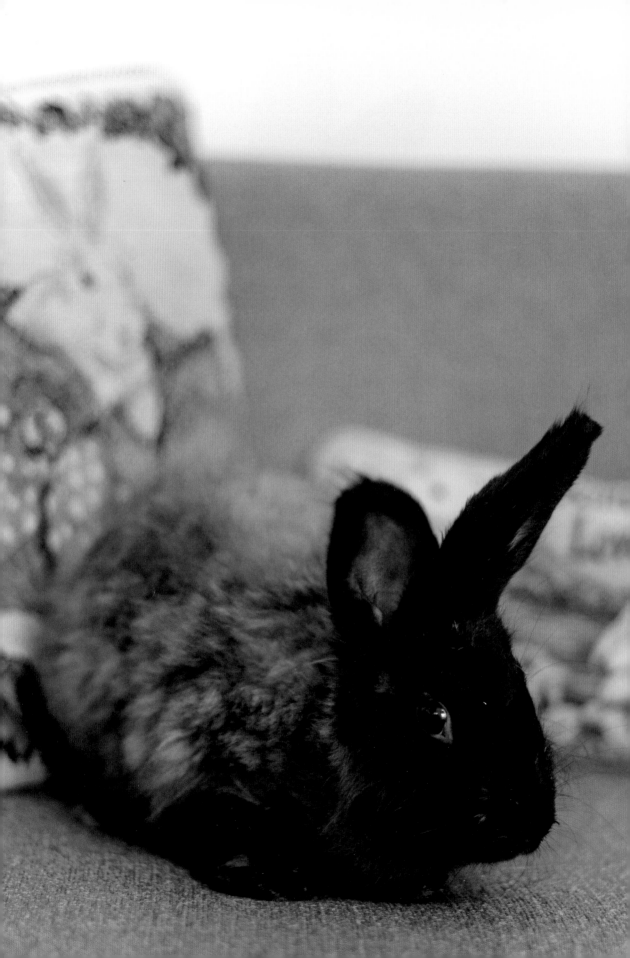

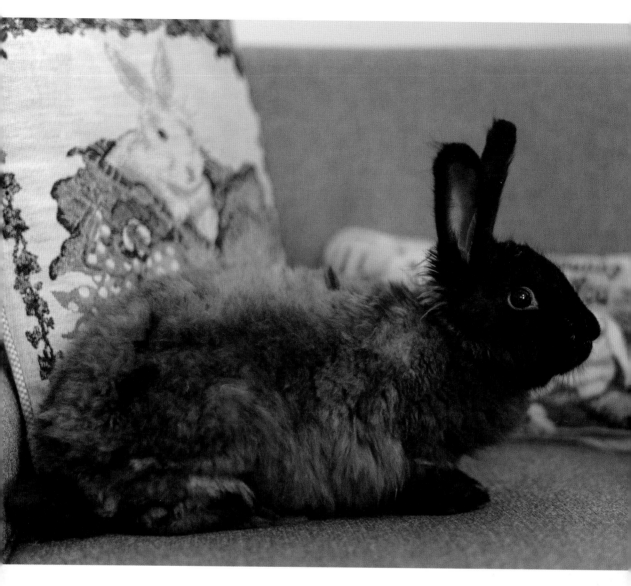

Anika

(*previous page and above*) Anika is a young Angora rabbit who is roughly a year old. She was confiscated from a home in Lafayette, Indiana, along with eighty other rabbits! She is now in a foster home, where she receives the attention and care she needs. Because of her breed, she requires regular grooming so that her coat doesn't become matted.

Opal

Opal is an adult mixed-breed rabbit who was taken in by a rescue in December 2016, along with thirteen other rabbits, when her owner could no longer care for all of them. She was in rescue for a while before being adopted, as her shy nature caused her to be overlooked for the more outgoing bunnies.

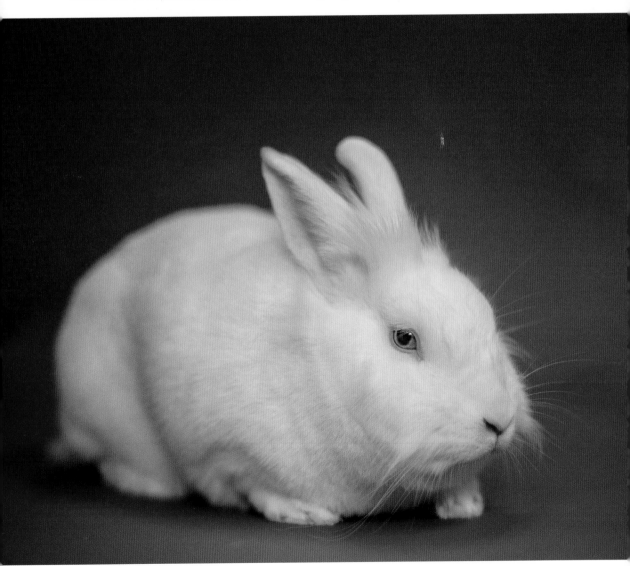

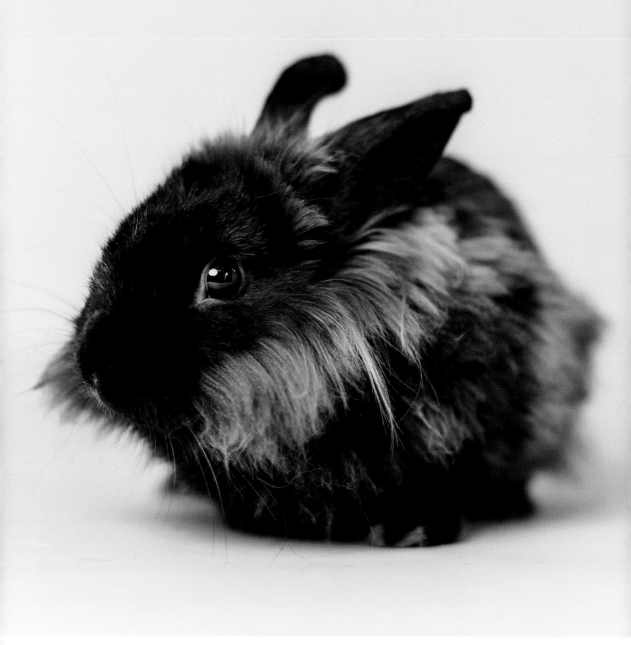

Magellan

Magellan is a shy, young Lionhead rabbit. He was in rough shape when he ended up in rescue. Fortunately, this little guy found a loving home that understands his physical and emotional needs.

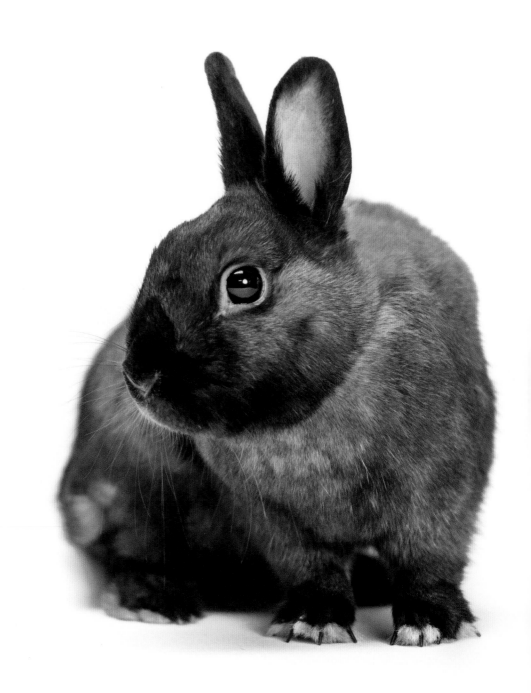

Aubree

Aubree is a sweet little rabbit; most likely a Netherland Dwarf mix. This tiny, friendly girl is lucky to have found her forever home.

Whispy

(below and following page) Whispy is a Lionhead mix (most likely mixed with a Californian rabbit, known for their dark noses and ears). She was brought to a small rescue along with thirteen other members of her herd when their owner could no longer care for them. When brought into rescue, Whispy wasn't a big fan of human interaction; however, despite this, she was adopted into a loving home.

Whispy's age is unknown, but you can see how in just a couple of months the coloring on her nose and ears lightened. It is not uncommon for a rabbit's fur to change color.

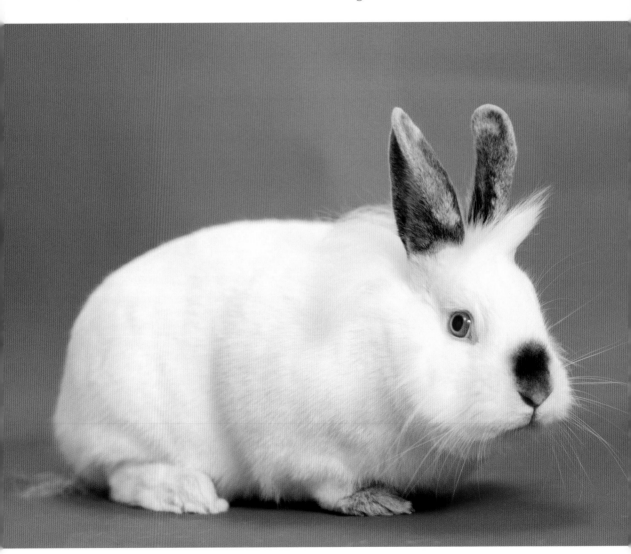

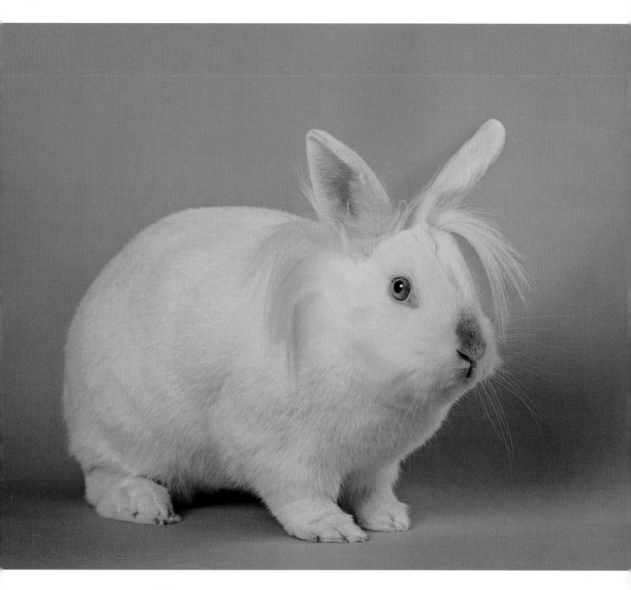

"IT IS NOT UNCOMMON FOR A
RABBIT'S FUR TO CHANGE COLOR."

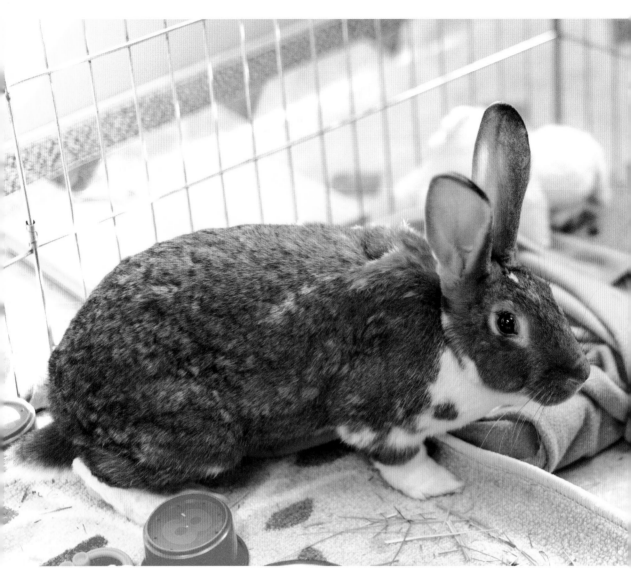

Dasher

Dasher is a young female Continental-mix rabbit who was rescued, along with her siblings, right before Christmas. A Good Samaritan discovered that the campground petting zoo where they lived was going to sell them back to the person they were originally obtained from, so he could kill them for meat. Lucikily, Dasher is now living large in her new home.

Dancer

Dancer, like her sister, Dasher, is a young Continental-mix rabbit. She is one of eight rabbits that were rescued from a petting zoo before they could be sold and killed for meat. Continental mixes are not officially a recognized breed in the United States, but a similar breed, the Flemish Giant, is recognized as the largest breed in the U.S. Dancer is now safe in her forever home.

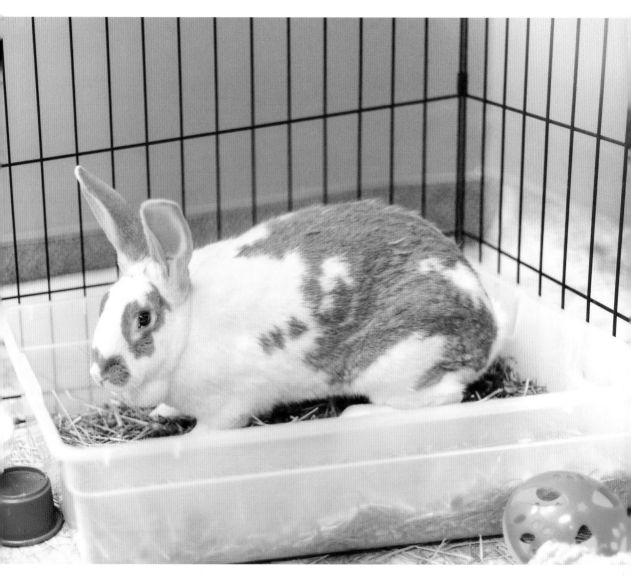

Scout

(below and following page) Six-year-old Scout was found as a stray in a park with her brother, Jim, and brought to rescue and moved into a foster home. She was a little nervous when meeting new people, so her foster family decided to adopt her after they lost their thirteen-year-old bunny.

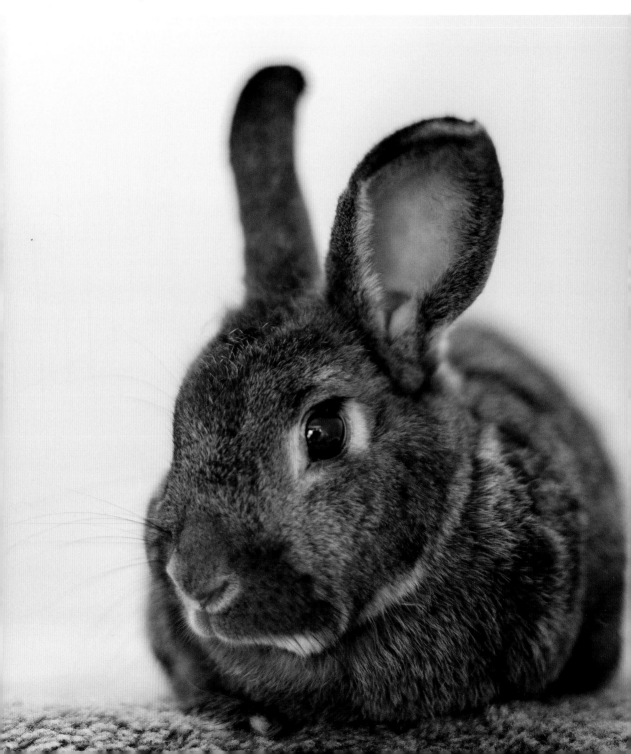

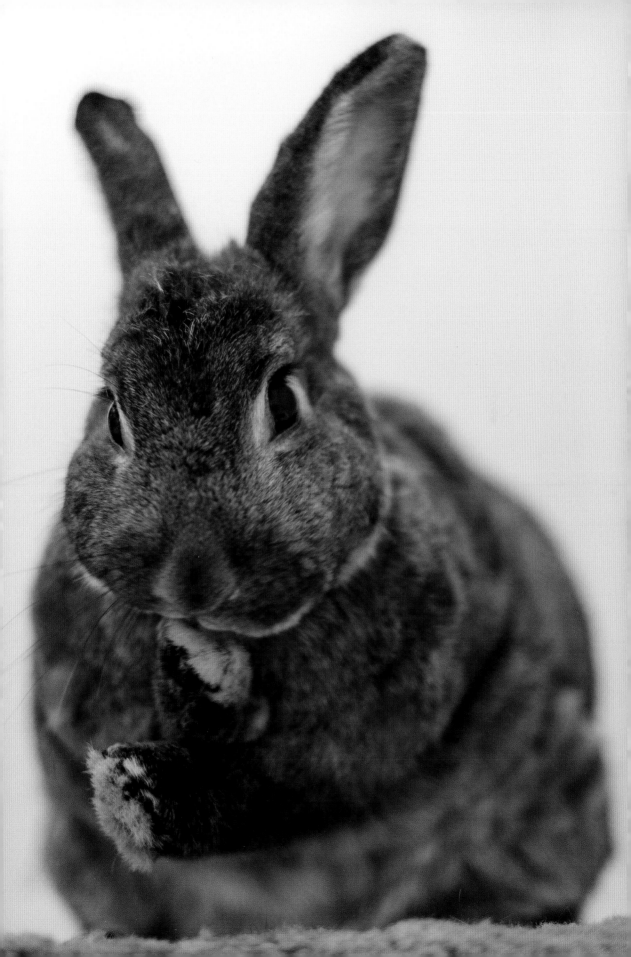

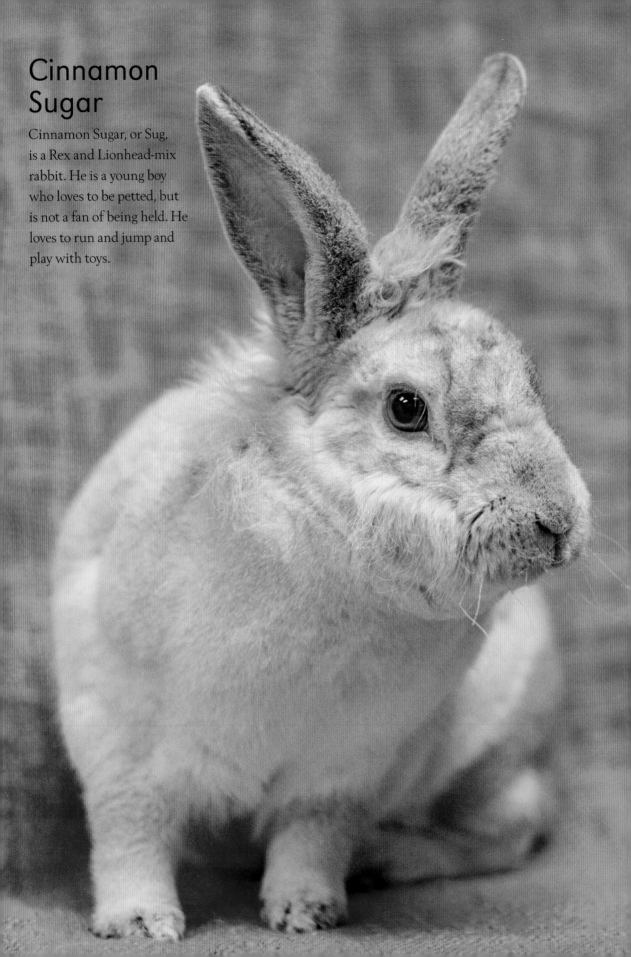

Cinnamon
Sugar

Cinnamon Sugar, or Sug,
is a Rex and Lionhead-mix
rabbit. He is a young boy
who loves to be petted, but
is not a fan of being held. He
loves to run and jump and
play with toys.

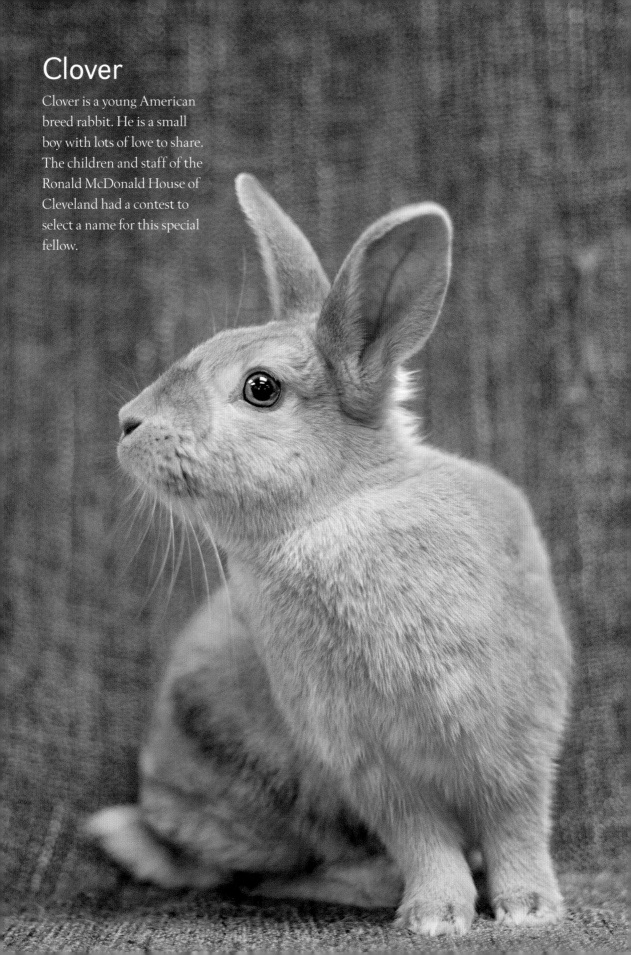

Clover

Clover is a young American breed rabbit. He is a small boy with lots of love to share. The children and staff of the Ronald McDonald House of Cleveland had a contest to select a name for this special fellow.

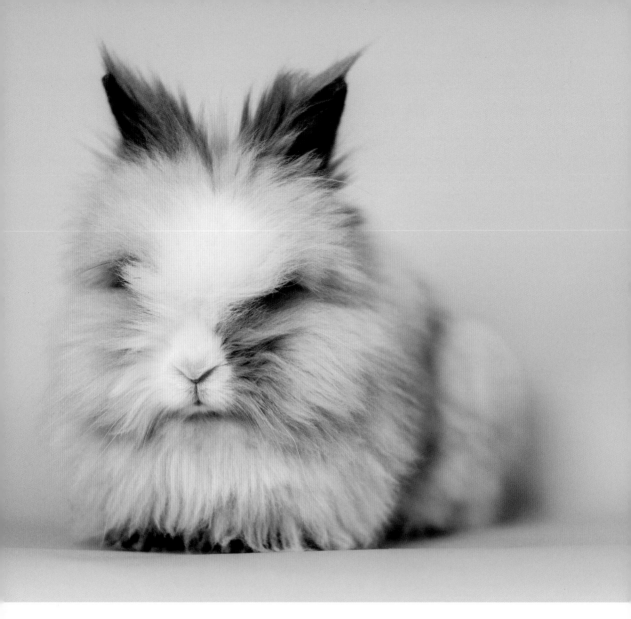

Bella

(above and following page) This adorable ball of fluff is a young, blue-eyed, blond-haired Jersey Wooly. Because of their fluffy coats, Jersey Woolies require regular grooming. Fortunately, Bella loves her spa days. Jersey Woolies are known for their gentle, even temperaments, and Bella is no exception. It wasn't long before this sweet girl was adopted, and she quickly bonded with a male bunny companion.

"JERSEY WOOLIES ARE KNOWN FOR THEIR GENTLE, EVEN TEMPERAMENTS, AND BELLA IS NO EXCEPTION."

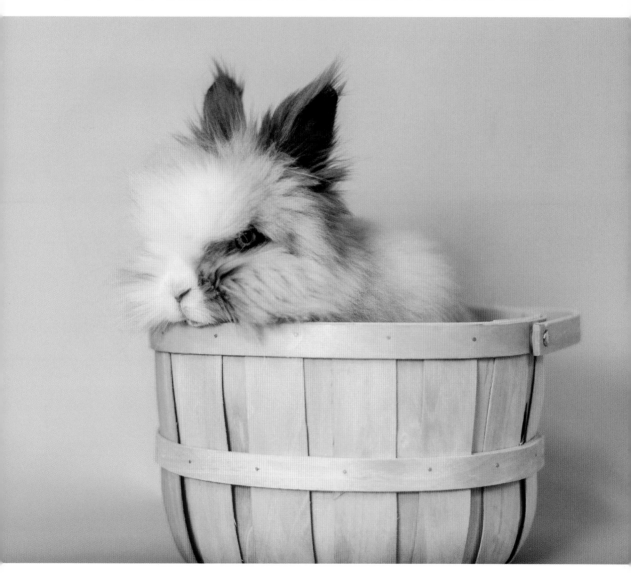

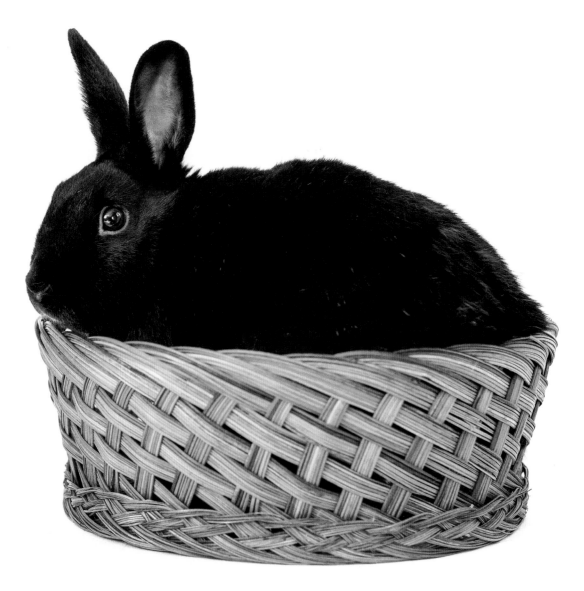

Silk

Silk is a mixed-breed rabbit who came to rescue in December 2016, along with thirteen other rabbits, whose owner could no longer care for them. He is very friendly, loves to play, and especially loves eating treats. Fortunately, Silk has a home of his own now, where he can do all the things he loves.

Diana

Diana is a mixed-breed rabbit who loves attention and snuggling. She is very patient and outgoing and good with children (not all rabbits are), which is why she quickly found a forever home.

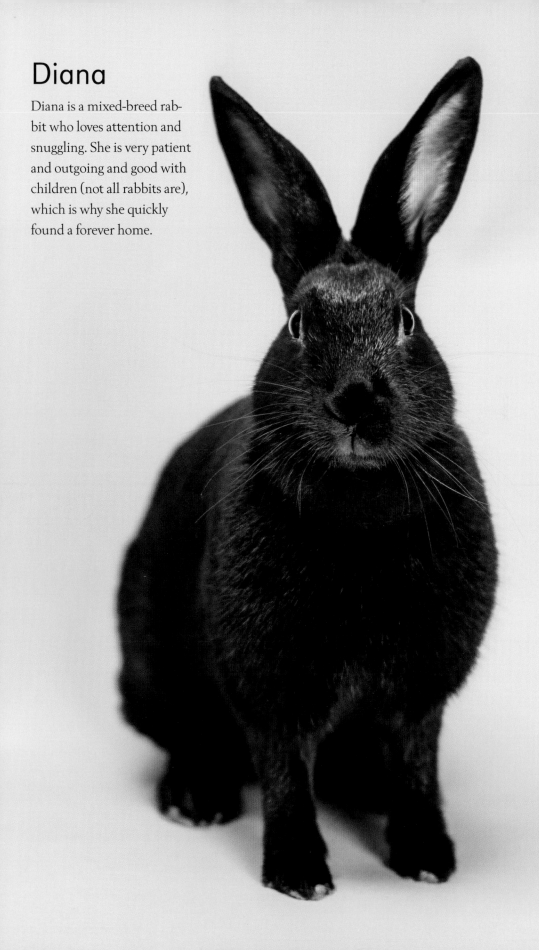

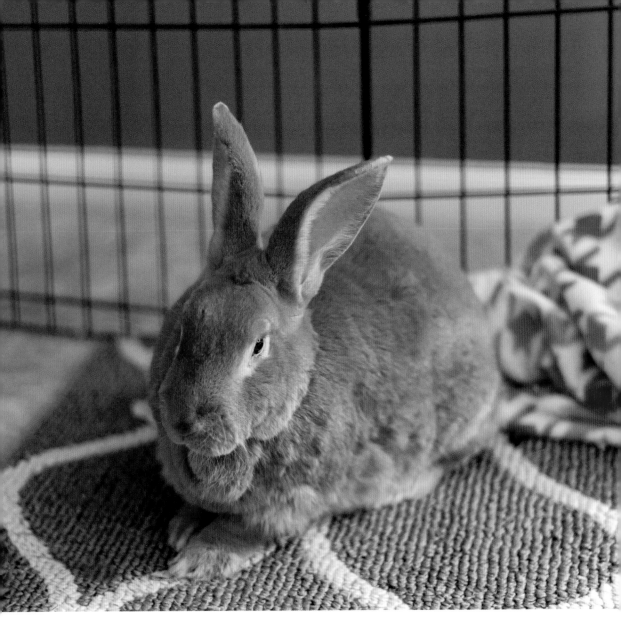

Hank

Hank is a Continental-mix rabbit who was rescued from a
Northern Ohio campground where he was going to be sold
for meat. He was taken in by a rescue in Columbus, Ohio,
that eventually rescued eight other related rabbits, saving
them from the same fate. Hank is now living it up in his
adoptive home.

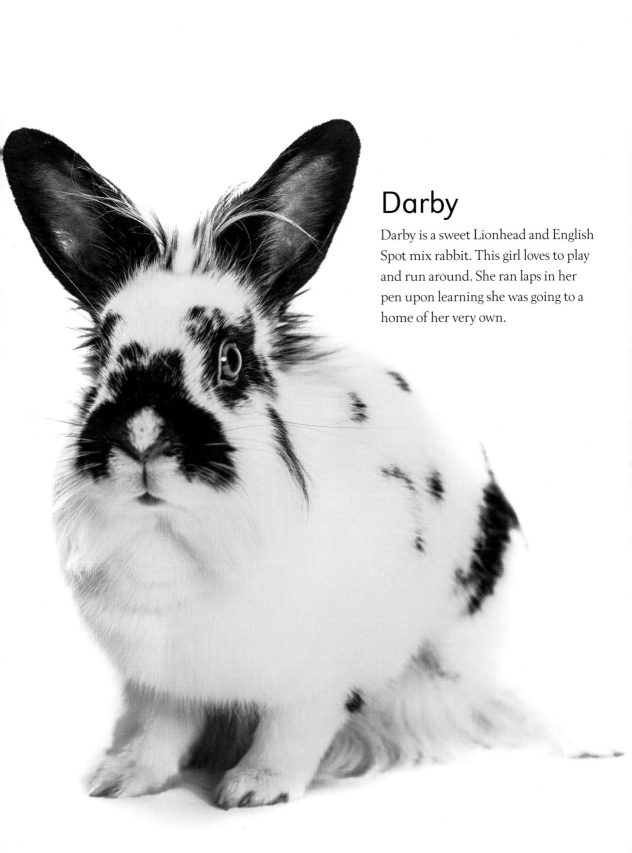

Darby

Darby is a sweet Lionhead and English Spot mix rabbit. This girl loves to play and run around. She ran laps in her pen upon learning she was going to a home of her very own.

Pemma

Pemma is a sweet young rabbit who was rescued by a Good Samaritan who saw some baby bunnies being sold outside a grocery store in Northern Ohio. The individual was able to purchase four of the bunnies and brought them to a rescue.

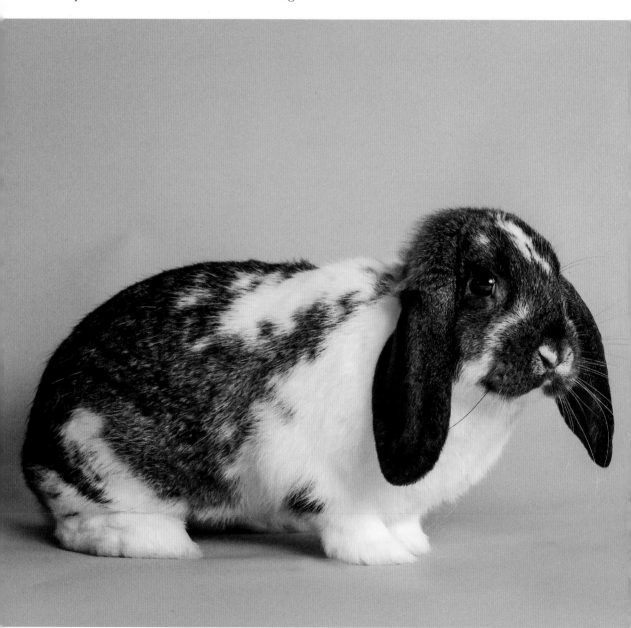

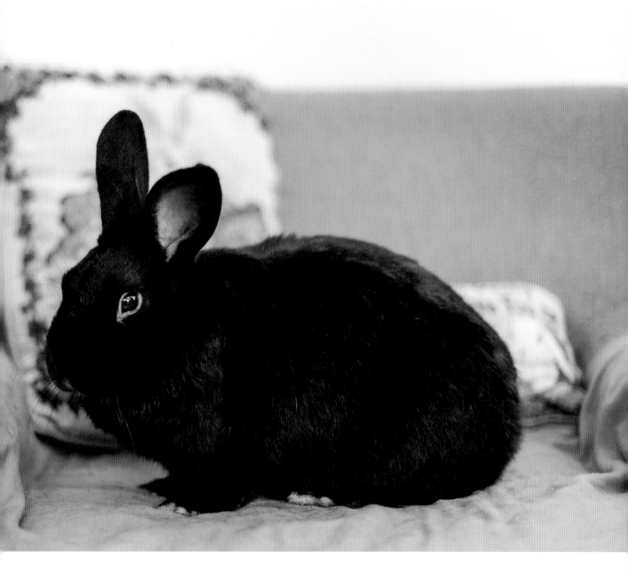

Preston

Preston is a young black New Zealand mix rabbit. His original owner surrendered him to an animal shelter, but Preston was not thriving in that environment. Luckily, he was taken in by a rescue and now lives in a foster home.

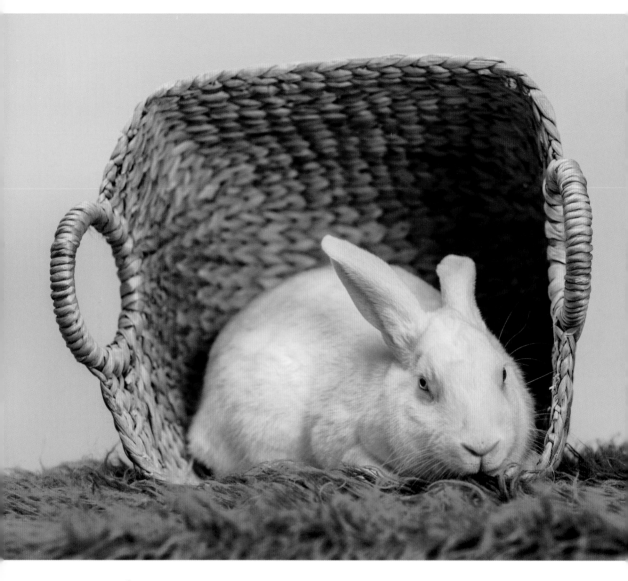

Lorelai

Lorelai is a large mixed-breed white rabbit. She is shy and a little skittish when she encounters new situations. She is looking for a quiet place to call home.

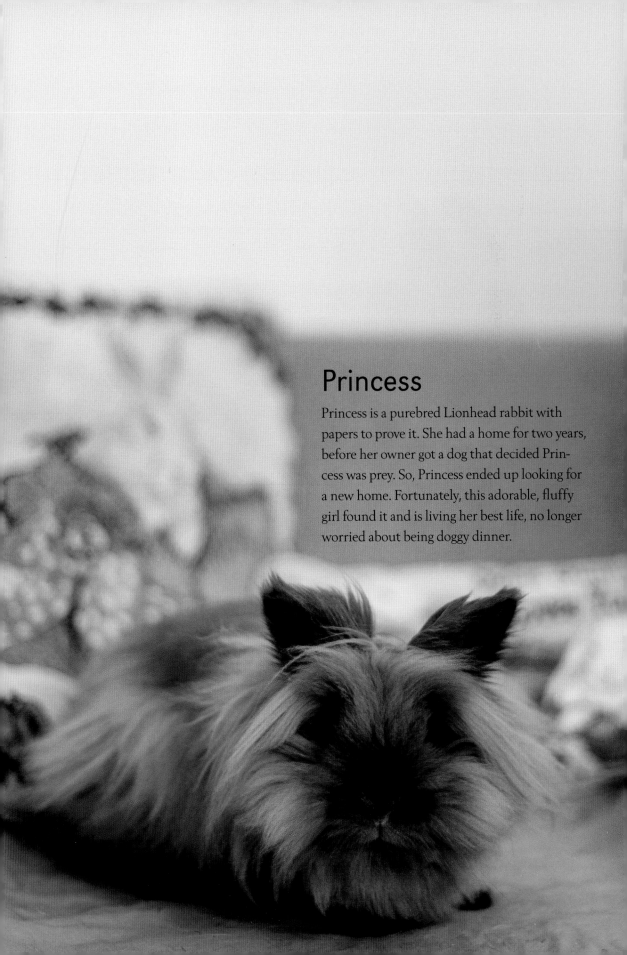

Princess

Princess is a purebred Lionhead rabbit with papers to prove it. She had a home for two years, before her owner got a dog that decided Princess was prey. So, Princess ended up looking for a new home. Fortunately, this adorable, fluffy girl found it and is living her best life, no longer worried about being doggy dinner.

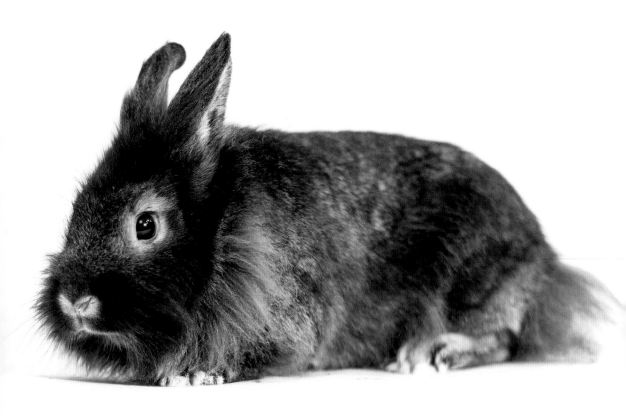

Black Beauty

(*above and following page*) Black Beauty is a Lionhead-mix rabbit. She was brought to rescue along with her thirteen housemates when their owner could no longer care for them. She loves nothing more than to sit on your lap while you smooth her fluffy coat. This easygoing bunny was adopted into a loving home.

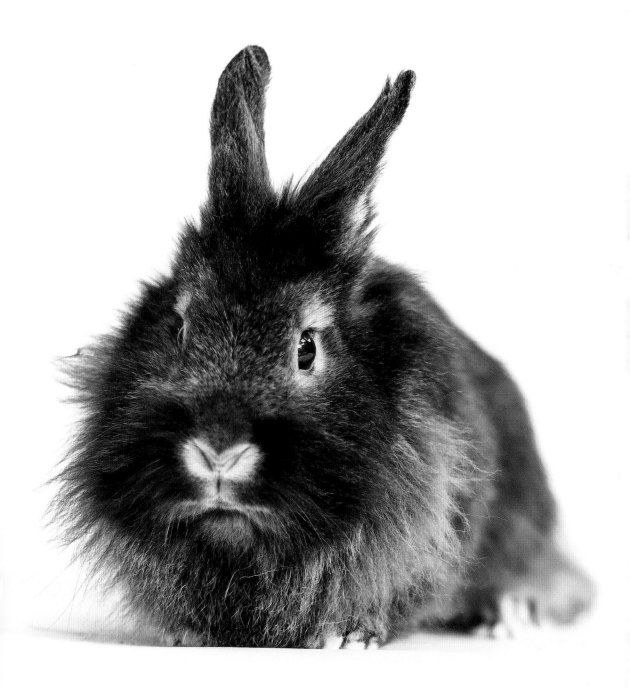

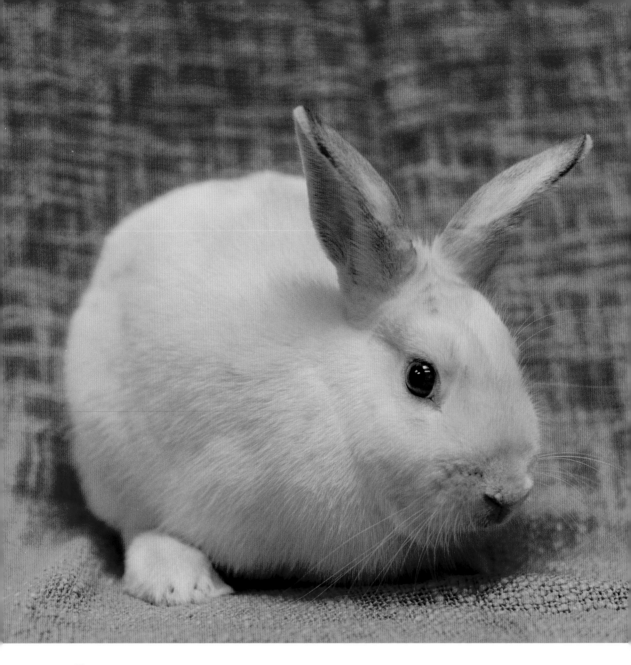

Bean

Bean is a small, young American rabbit who is about one
year old. His mom was caught outdoors as a stray, and Bean
was born in rescue. He is a sweet, friendly, and active bunny
looking for a home of his own.

Ebony

Ebony is a young, lively, and entertaining bunny who enjoys being petted by anyone who visits her. She even enjoys bunny yoga. She would be a great partner for a bunny looking to bond.

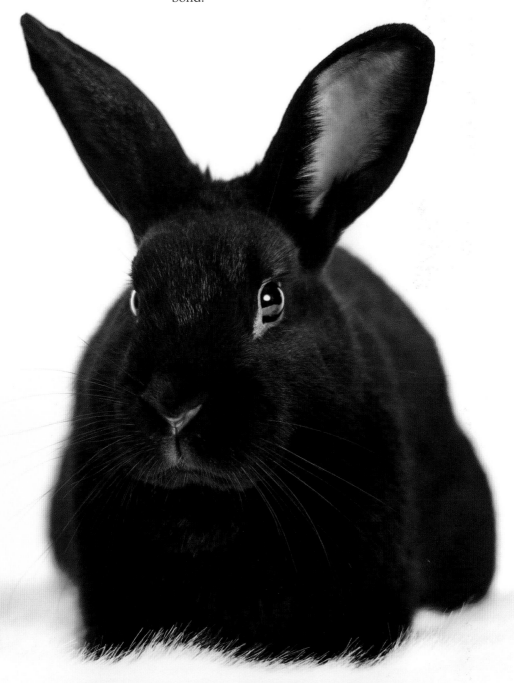

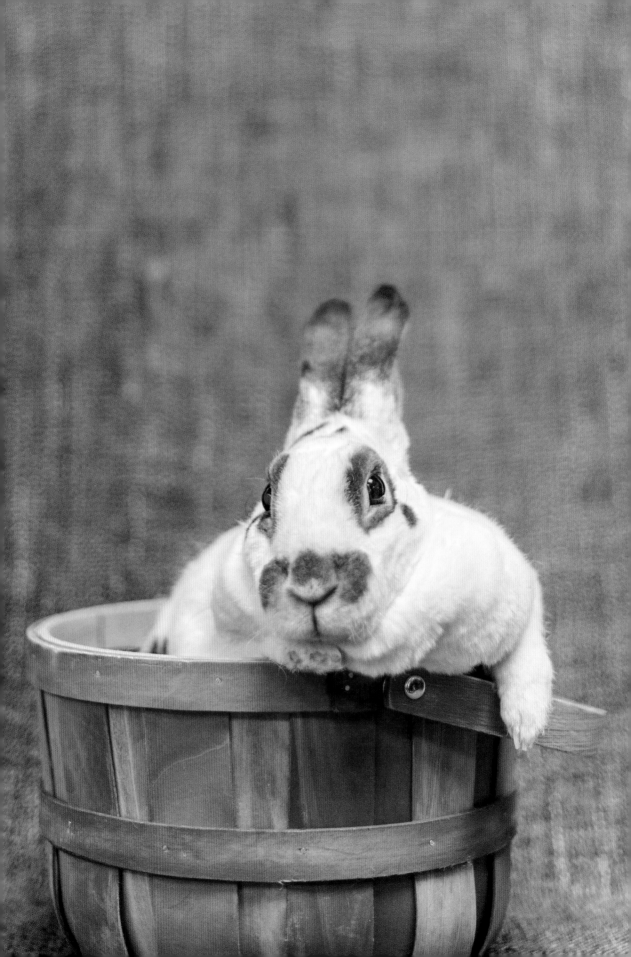

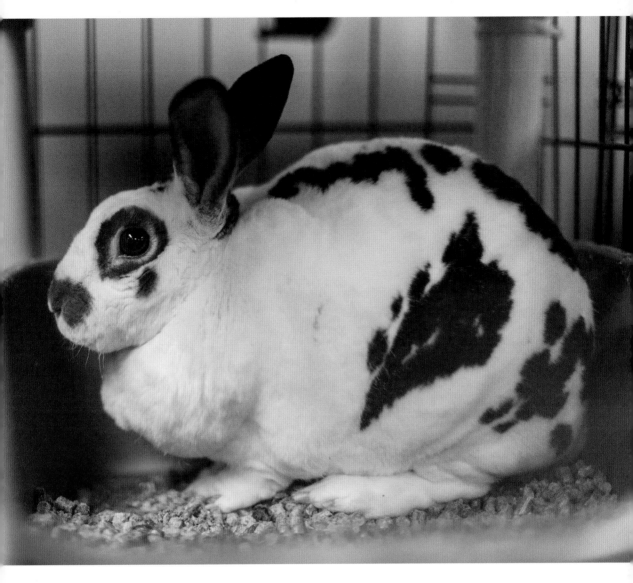

Kissea

(*previous page and above*) Kissea is a shy young Rex who loves to be petted. She was found dumped outside and subsequently had babies. Fortunately for Kissea, she has a happy adoptive home where she can get as much petting as she wants.

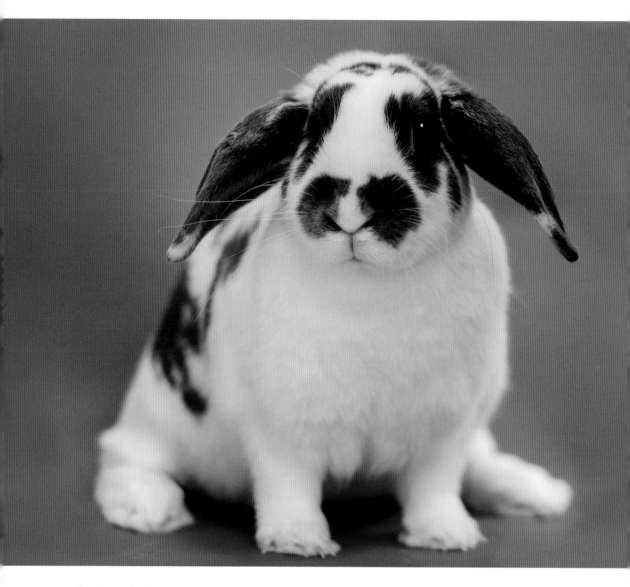

Marbles

Marbles is an adorable female Mini Lop who was found as a
stray before being brought to rescue. She is very curious and
loves attention. Fortunately for Marbles, she found a home
where she can get the pampering she craves.

Kelly

Kelly, an English Spot mix, was found as a stray and turned in to the local humane society. From there, she ended up in a rescue, where she lived in foster care. She is about one-and-a-half years old and very playful. She loves to run around and explore. One of her favorite things to do is tear up newspapers. This friendly girl is now happy in her new home.

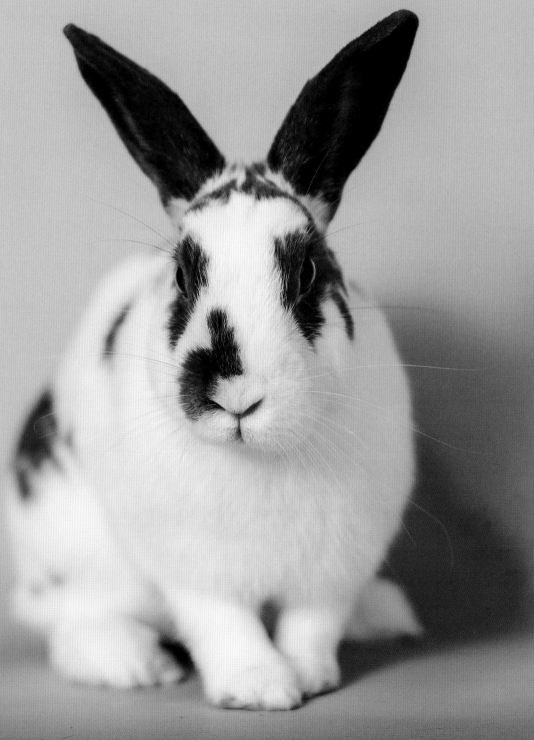

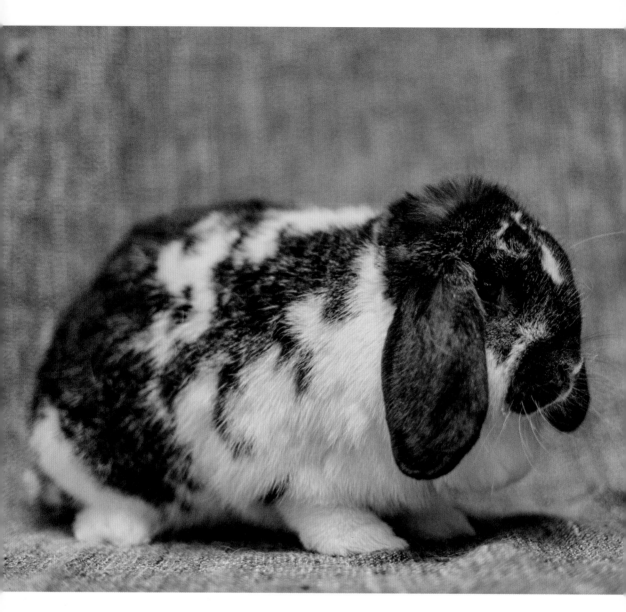

Mopsy

Mopsy, a sweet Mini Lop, is a little skittish when it comes to meeting people, and it's no wonder: this poor girl was used to breed for an educational farm and was kept in a petting zoo. Poor Mopsy was on her way to a meat market when she was rescued. She is looking for a safe, calm home of her own, where she never has to worry about grabbing hands again.

Nugget

Nugget is a large male Rex-mix rabbit. He was with his rescue for quite a while before he was adopted. Black rabbits, just like other black pets, spend longer in shelters or rescues prior to being adopted.

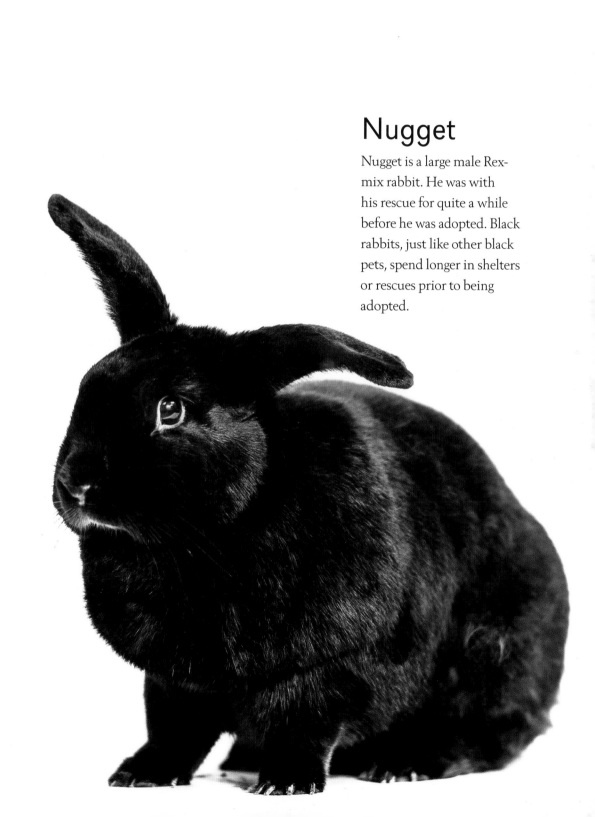

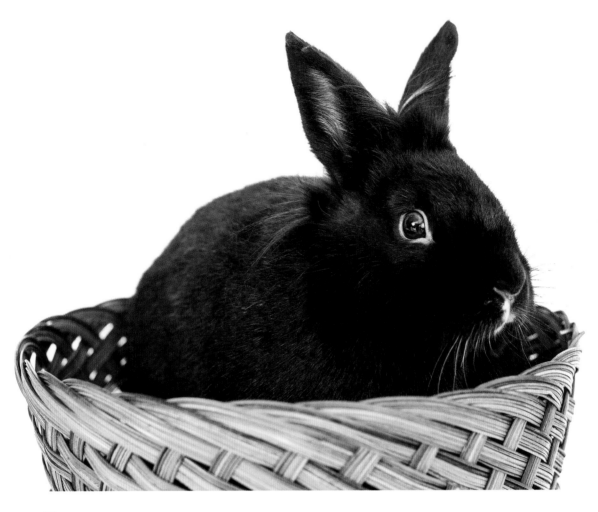

Emmett

Emmett is an adult Lionhead-mix who was brought into
rescue along with thirteen other bunnies in December 2016,
when their owner could no longer care for them. He is a shy
rabbit, but loves to explore. Fortunately, he now has his own
home to discover.

Zane

Zane, a little, blue-eyed ball of fluff, is approximately two years old. He ended up in rescue after his owner kept having her rabbits breed and wound up with too many bunnies. It's important to make sure that bunnies are spayed and neutered. After all, where do you think the saying "breed like rabbits" comes from?

Rupert

(previous page and above) Rupert is a young and friendly Holland Lop. Holland Lops are non-aggressive, small rabbits averaging about three-and-a-half pounds. Rupert was adopted from a local animal shelter along with his very shy sister. He is an easygoing bunny and is very happy in his forever home.

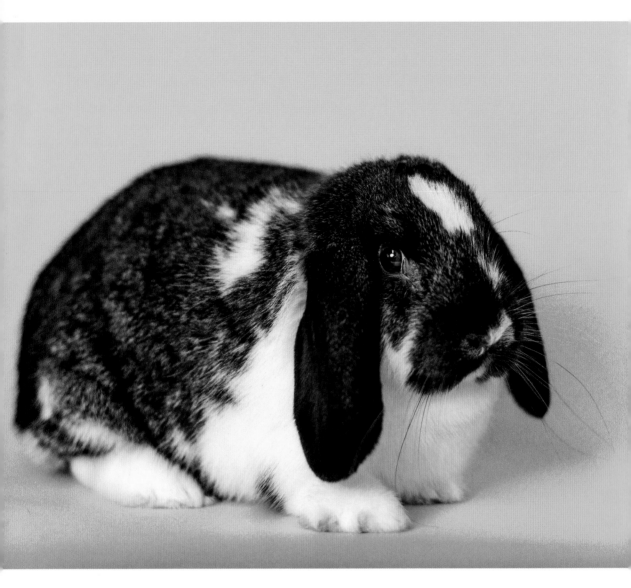

Butterfly

Butterfly is a pretty young Mini Lop, roughly six months old, who was rescued from a backyard breeder. This little bunny is now happy in her adoptive home.

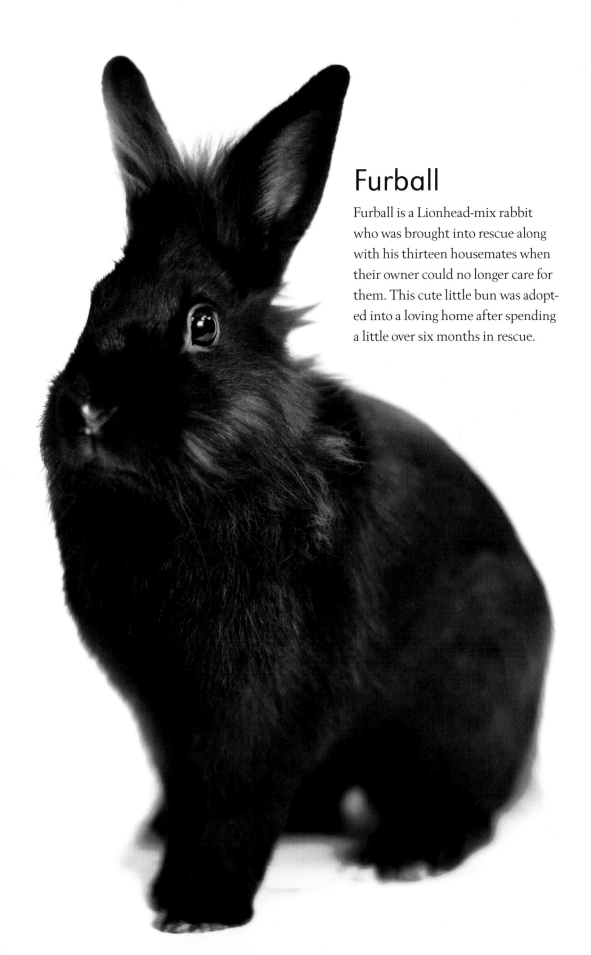

Furball

Furball is a Lionhead-mix rabbit who was brought into rescue along with his thirteen housemates when their owner could no longer care for them. This cute little bun was adopted into a loving home after spending a little over six months in rescue.

Tilly

(below and following page) Tilly is an adorable Rex rabbit who has been in rescue since November 2015. She has a cute personality and is very curious and adventurous. She is cautious when meeting new people, but warms up once she gets to know you. She is blind in one eye, but that doesn't hinder her at all.

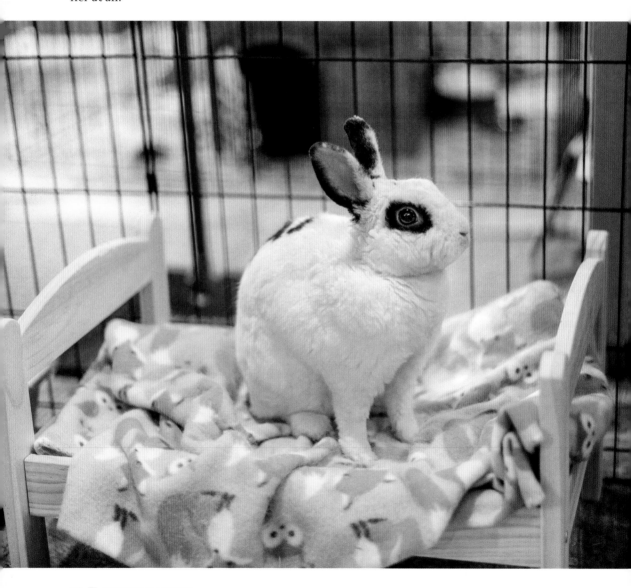

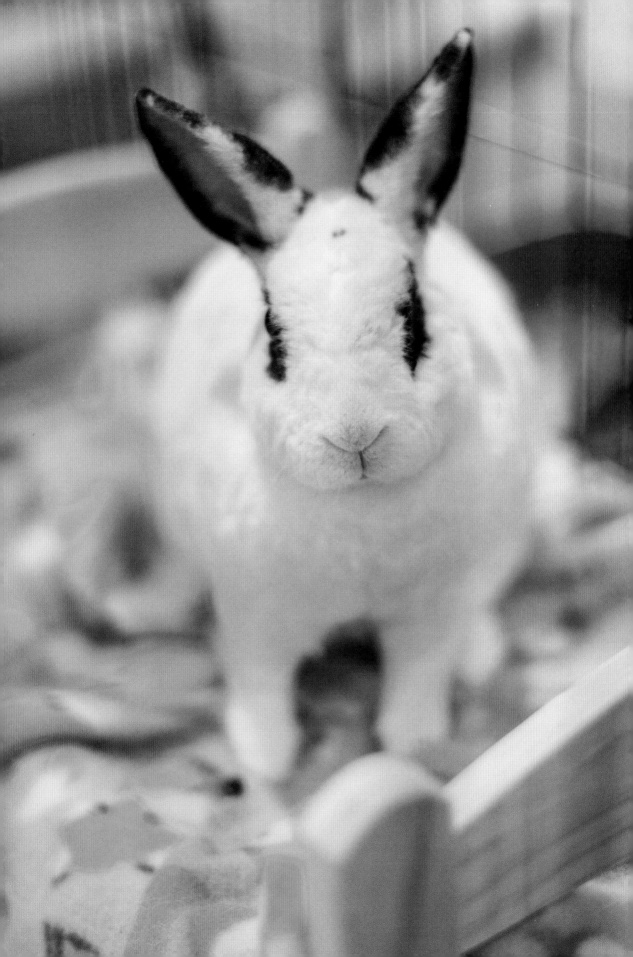

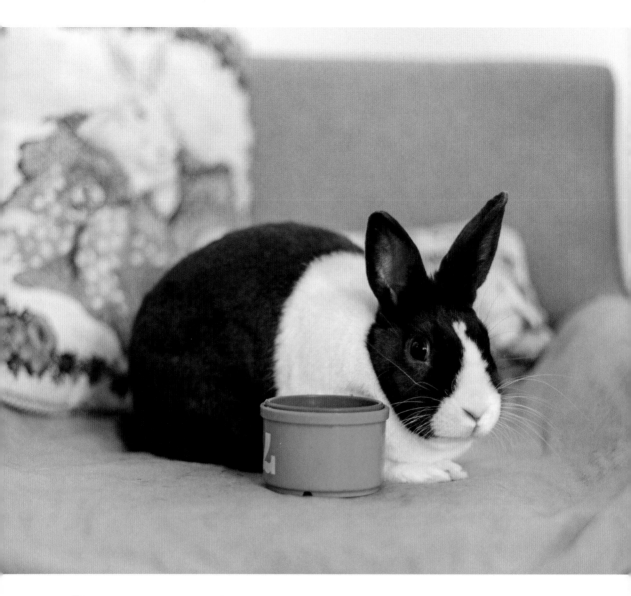

Pepper

Pepper is a sweet, dark-brown and white purebred Dutch rabbit. She was found as a stray before ending up with a rescue. She is very playful and loves to be petted on the nose. She lived in foster care before being adopted into a loving home as a companion for her adopters' rabbit, Dutch. Her new family also adopted a bonded pair from the rescue.

R2

R2 was born around Christmas 2016, and it wasn't long before this adorable young Lop-Eared bunny was adopted into a loving home.

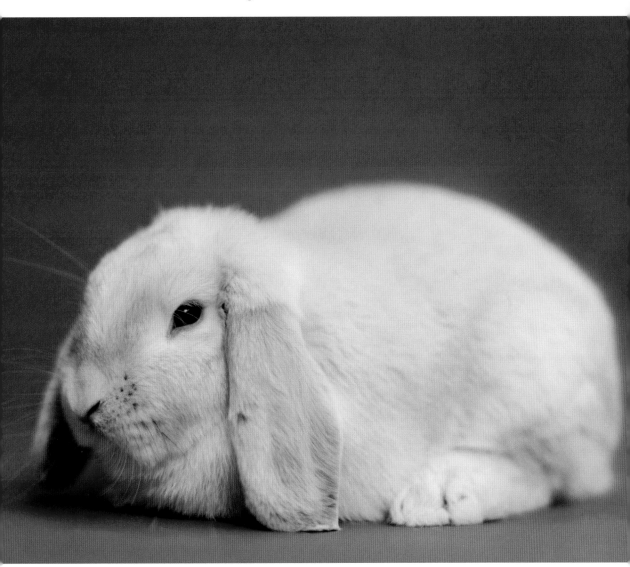

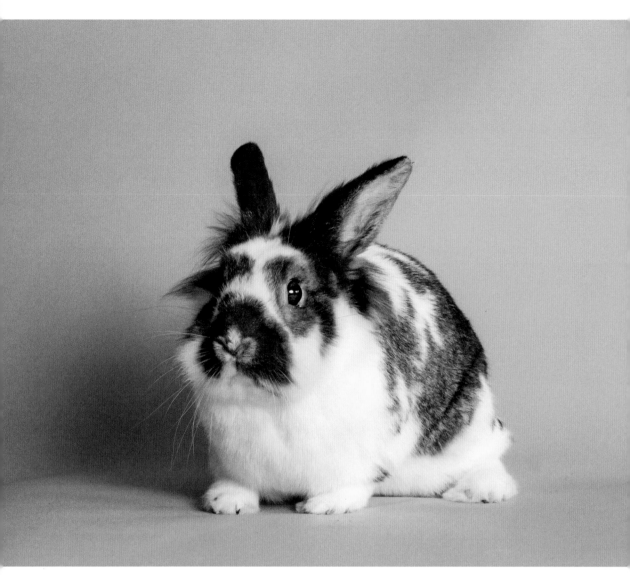

Franzia

Franzia, a two-year-old bunny, came from a breeder hoarding situation in Oklahoma. She was brought to rescue in Cleveland, Ohio, where she lived in a foster home and ended up being a "foster fail." A "foster fail" is when the foster parent ends up adopting their foster pet . . . so it's not really a fail at all!

Jasmine

Jasmine is a young black Satin-mix rabbit, just under one year old. She has a big personality and loves to explore. She would love to find a home of her own.

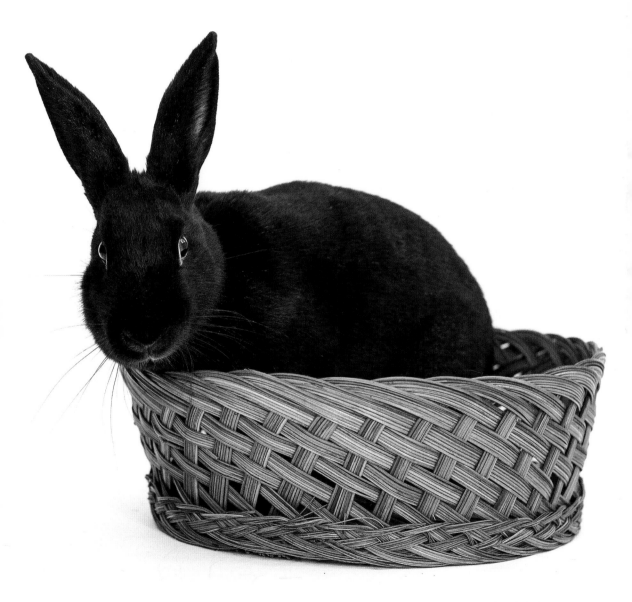

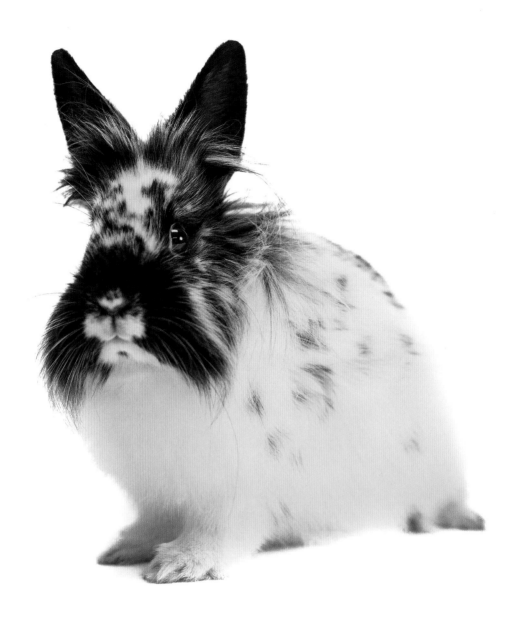

Finch

(*above and folowing page*) Finch is an adorable young Lionhead-mix rabbit. He has a great personality and is very friendly. This cute guy didn't spend too long in rescue before he was adopted.

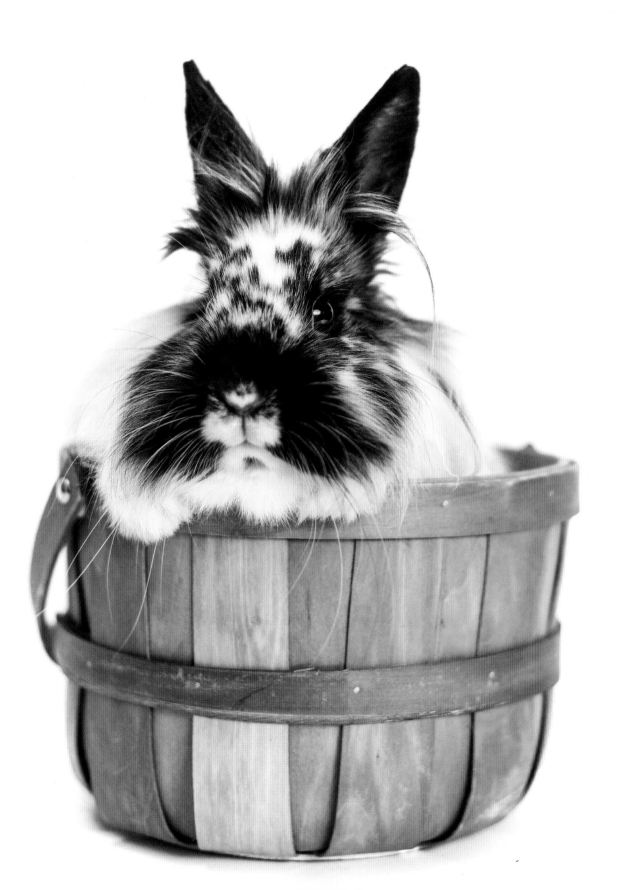

Poppy

Poppy was found as a stray and brought to rescue. He is around two years old and is a Himalayan rabbit, a breed that's often mistaken for a Californian rabbit. Himalayans are one of the oldest rabbit breeds.

Vera

Vera is a Dutch rabbit—one of the oldest breeds of domestic rabbits. This young girl was lucky enough to find a home of her own after spending a short time in rescue.

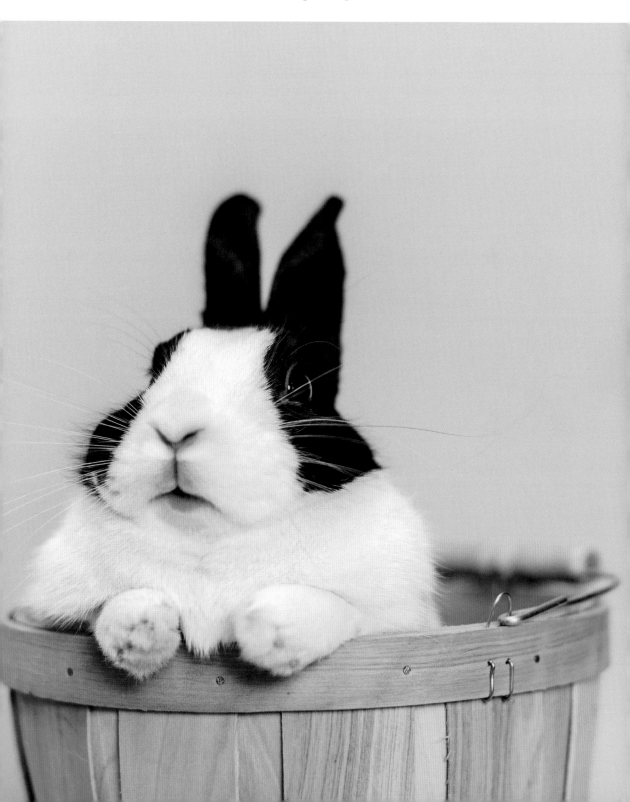

Turquoise

(*below and following page*) Turquoise, a Hotot mix, was
rescued from a backyard breeder in Pittsburgh, Pennsylvania, when the breeder placed an ad for rabbits on Craigslist.
He had forty rabbits in his garage that he was trying to sell
for Easter, and a local rescue organization stepped in to save
them. Turquoise was later transferred to his current rescue in
Northeastern Ohio, where he is interviewing for his forever
home.

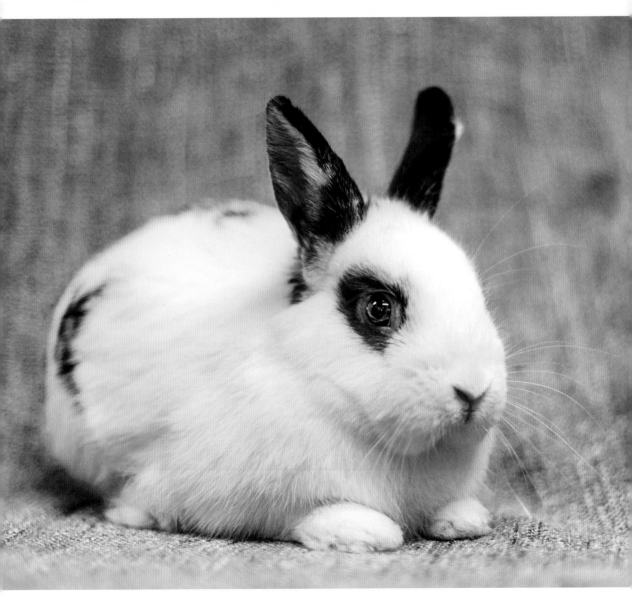

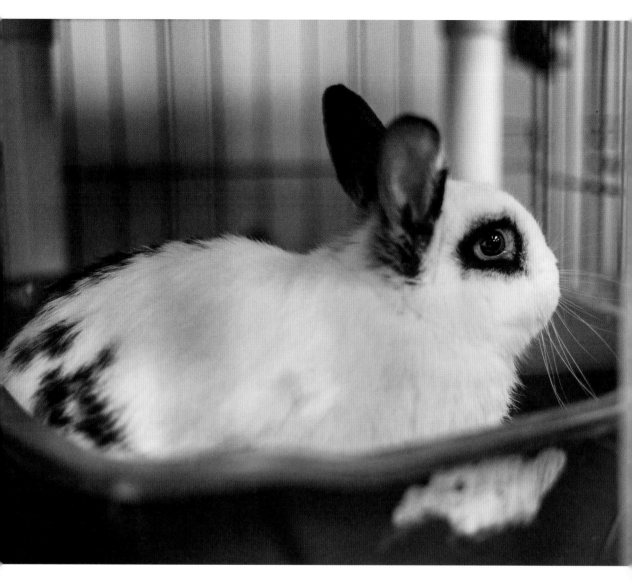

"TURQUOISE, A HOTOT MIX, WAS RESCUED FROM
A BACKYARD BREEDER IN THE PITTSBURGH AREA . . ."

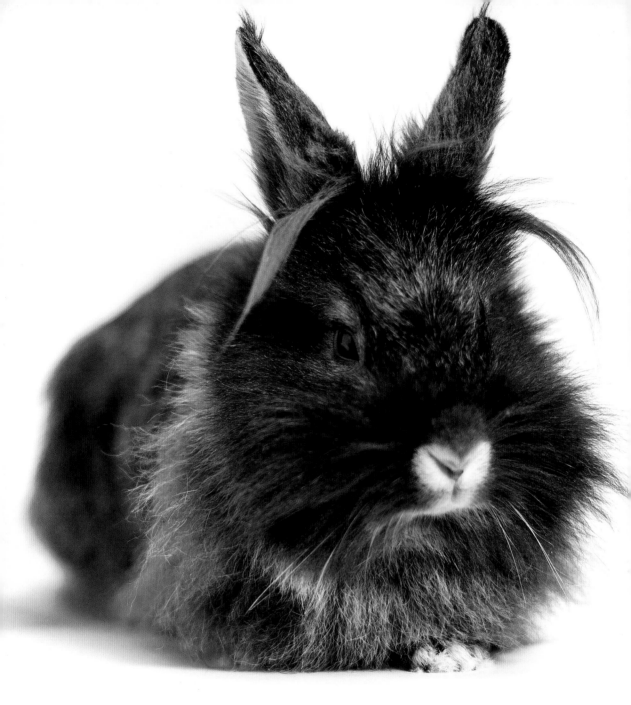

Penelope

Penelope is a Lionhead-mix rabbit brought to rescue from a home with thirteen other rabbits when their owner could no longer care for them. This adorable little bunny was adopted into a loving home after about six months in rescue.

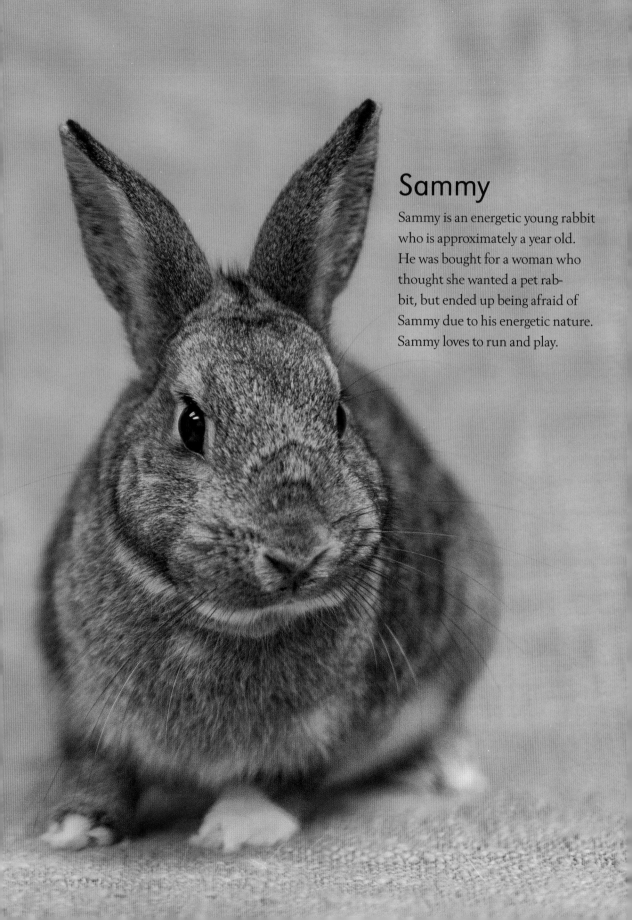

Sammy

Sammy is an energetic young rabbit who is approximately a year old. He was bought for a woman who thought she wanted a pet rabbit, but ended up being afraid of Sammy due to his energetic nature. Sammy loves to run and play.

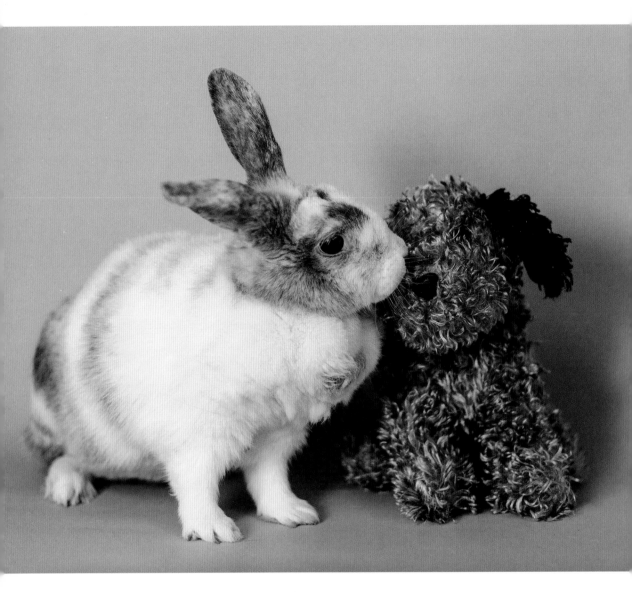

Kate

Kate is an adult Harlequin rabbit, estimated to be around two years old. She was found in a backyard in Toledo, Ohio, and brought to rescue. This house-trained rabbit is still looking for a home to call her own.

Q-Tip

Q-Tip is an adorable white Netherland Dwarf breed rabbit. His owner won him as a prize at a fair, but Q-Tip was surrendered to a rescue when his owner tired of caring for him. He is a very friendly, happy bunny who would love to find a family who will enjoy having him around for the rest of his life.

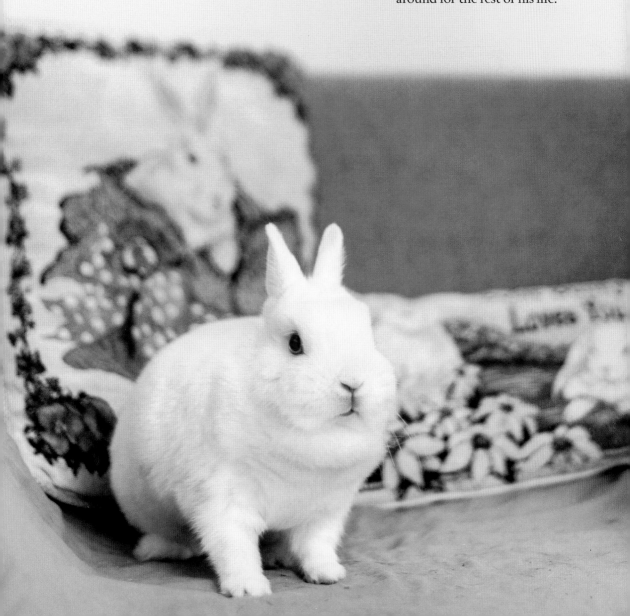

Carmel

Carmel is a young Harlequin mix under two years of age.
His parents were found as strays in Northeastern Ohio, and
Carmel was born in rescue, along with his siblings.

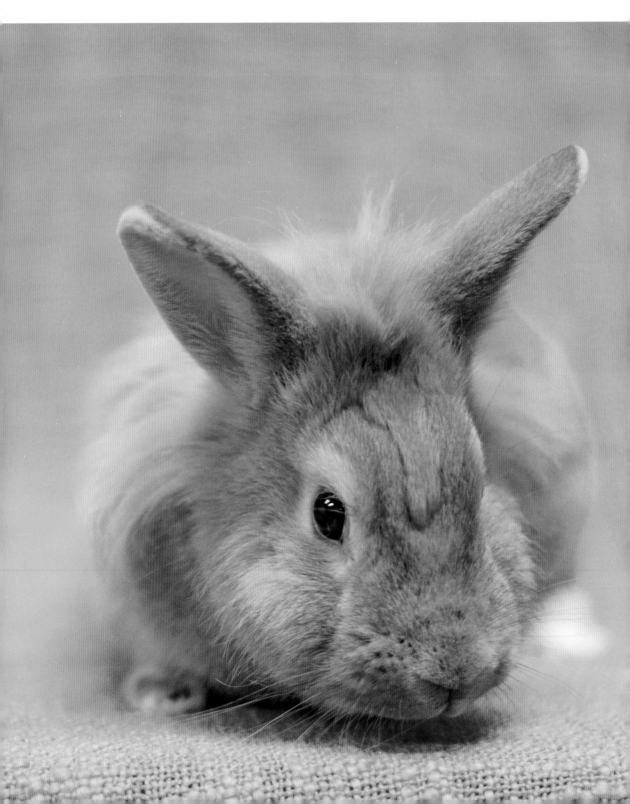

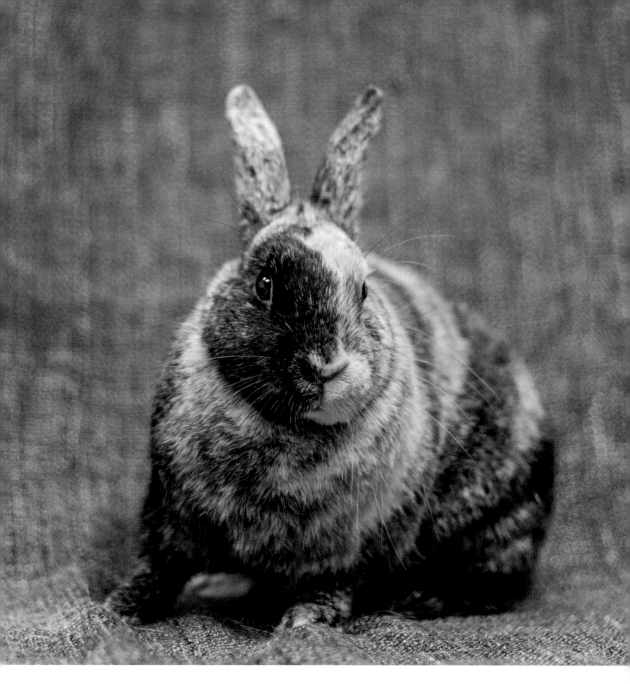

Tigerlily

Tigerlily is a beautiful Harlequin rabbit who was found running around a neighborhood along with her "husbun" and son, Daffy. Less than a week after she was rescued, she gave birth to a litter of kits ("kit" is short for "kitten"). Tigerlily is happy to be kit-free and is looking for someone to earn her trust and give her the attention she deserves.

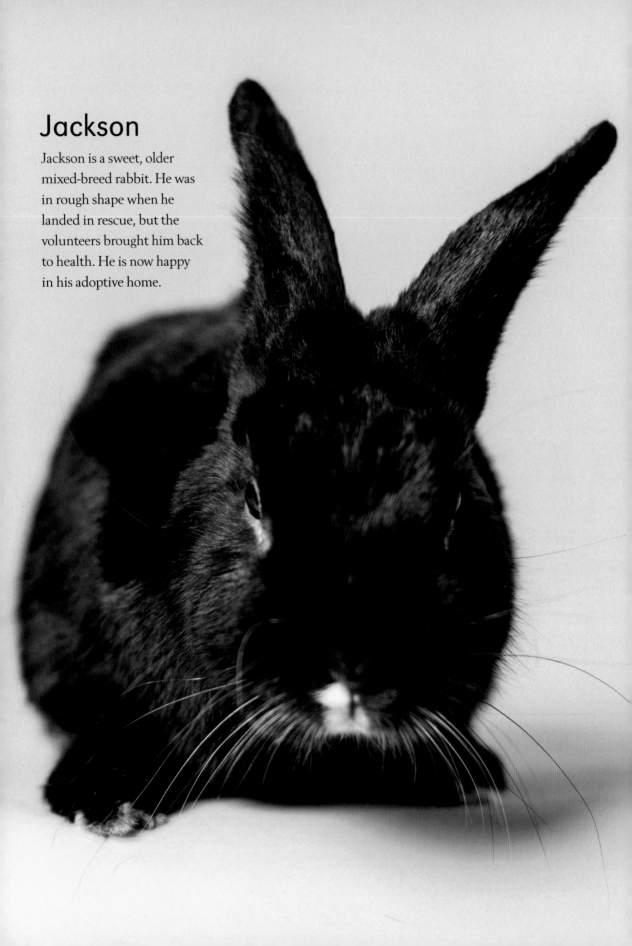

Jackson

Jackson is a sweet, older
mixed-breed rabbit. He was
in rough shape when he
landed in rescue, but the
volunteers brought him back
to health. He is now happy
in his adoptive home.

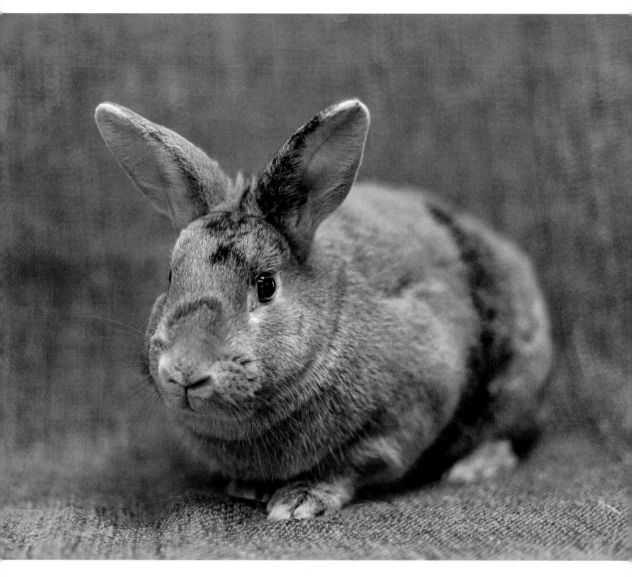

Whispa

Whispa is a small, young Harlequin rabbit—the only female in her litter. She is just under two years old and was born in rescue just three days after her mom arrived at the rescue. She needs some one-on-one attention and is interviewing for the perfect home.

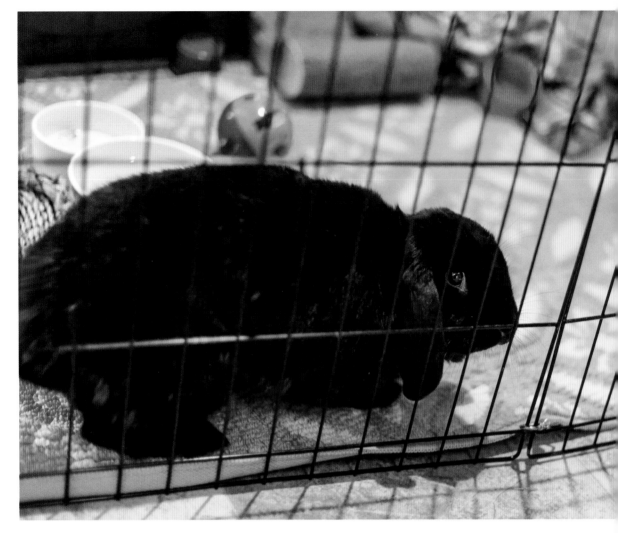

Annabel

Annabel has been in rescue since April of 2016. This Lop-Eared bunny is cautious with strangers, but will remember you once she knows and trusts you. She is a highly intelligent bunny who will make a loyal pet. She would love to find a home where she can roam freely.

Archie

Archie is a young New Zealand mix rabbit who was born into rescue. Archie spent three years in rescue before finally finding his happy home.

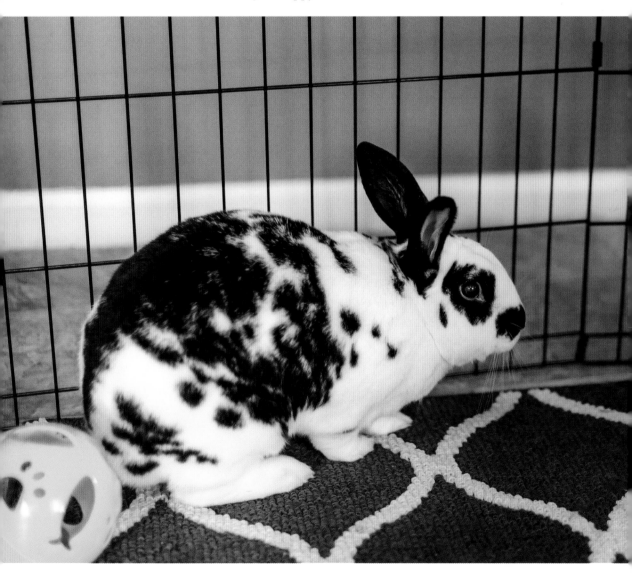

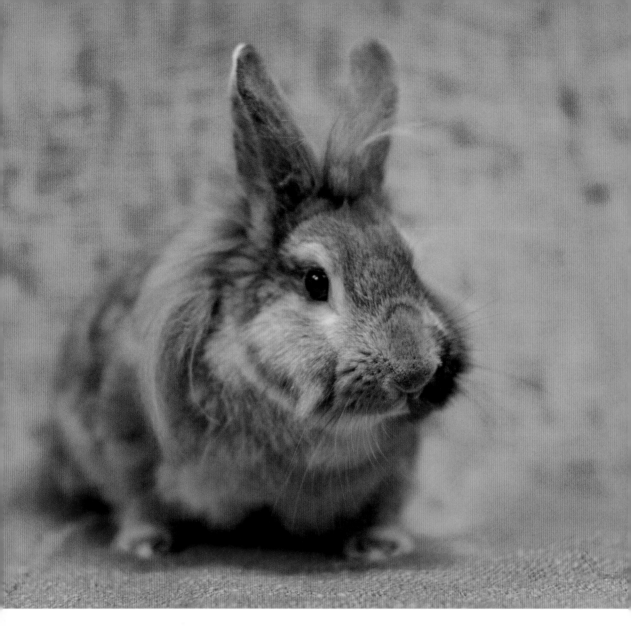

Daffy

Daffy, a young male Harlequin mix, has been in rescue for over a year and a half and was found as a stray, along with his parents. He is very sweet, but shy because he lived his entire life outside prior to being rescued. His rescue is working on socializing him so that his great personality can shine.

BONDED PAIRS

Thelma and Louise

Thelma and Louise are a bonded pair of "sisters." They had a home until their owner lost interest in caring for them, so they ended up being taken in by a rescue. They are around five-and-a-half years old. Thelma is a Harlequin, and Louise is a beautiful gray Rex.

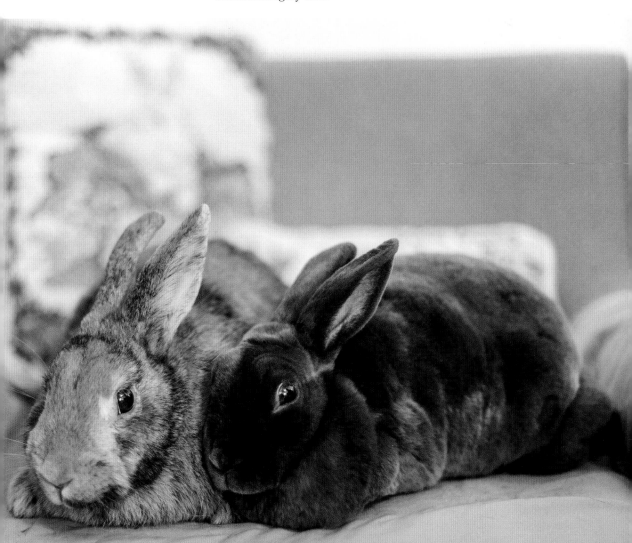

Gus and Daisy

Gus and Daisy are a four-year old bonded pair. Gus adores Daisy and loves to groom her, which this Jersey Wooly girl is in frequent need of because of her fluffy hair. Gus is an outgoing rabbit who loves people and adores hanging out with them. Daisy is a little more shy, and while she loves to explore, she prefers to stay by Gus's side. Both bunnies love to snuggle with each other and with people, too. Rabbits who have bonded in pairs are not split up for adoption and will stay in rescue until someone adopts both rabbits. Fortunately, these two were able to find a happy forever home together.

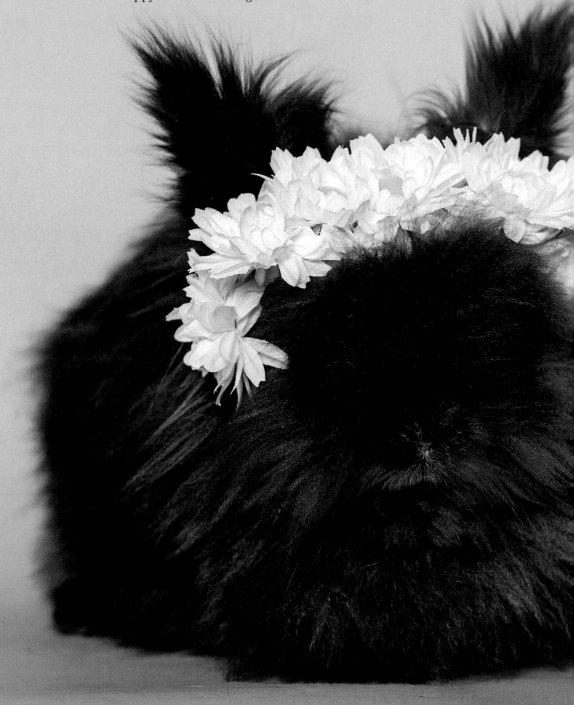

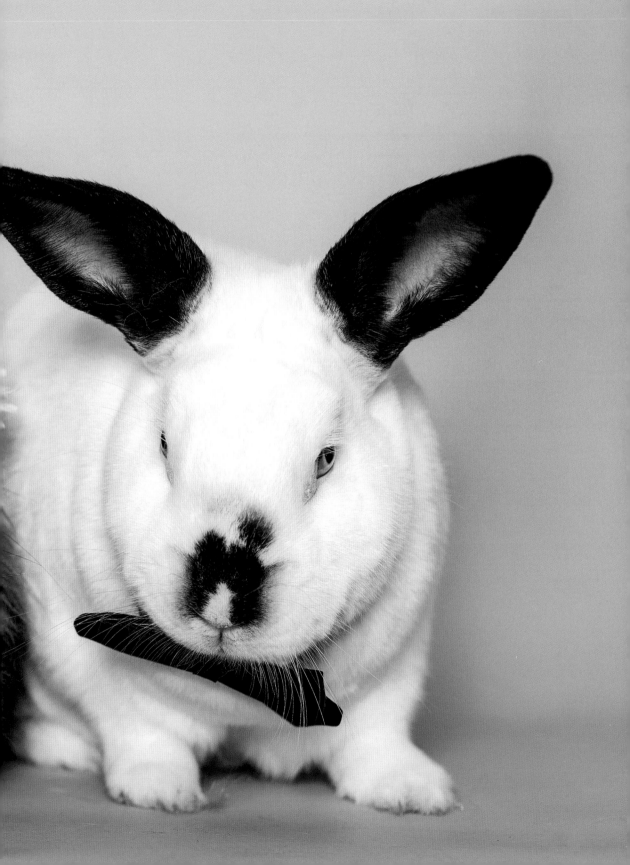

Tux and Pink

Tux and Pink are a newly bonded pair of bunnies. Tux is a large Dutch rabbit, estimated to be six years old. He came from a Kentucky shelter and had a partner rabbit who died. Pink is a big girl, around eight years old, who was found by a Good Samaritan in the rain in the middle of a busy road in Louisville, Kentucky, in 2011. The Good Samaritan contacted her bunny-loving friend in Northern Kentucky, who took Pink in. Tux and Pink were in neighboring pens in their home, and one day, Tux decided to hop over into Pink's pen. They became fast friends!

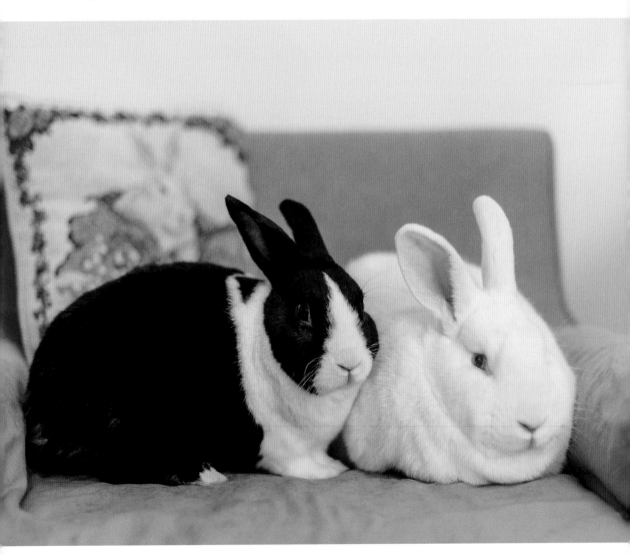

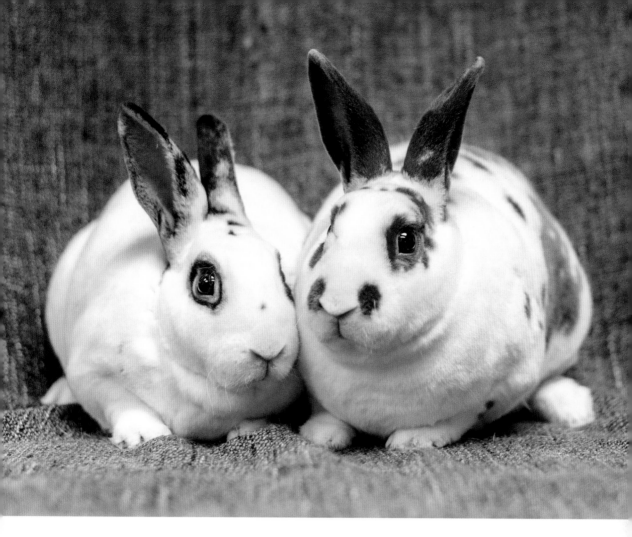

Foster and Regal

Foster (*left*) and Regal (*right*) are two young male Mini Rex rabbits. This bonded pair had a rough start in life; they were dumped in an area filled with predators. A third bunny abandoned with them was killed by an owl before he could be rescued.

Foster is a friendly boy, but needs time to warm up to people. Regal has overcome many obstacles in life: He was bit by a fly, which caused a warble (a lump where fly larvae is growing) in his dewlap, the fold of skin under the chin, and had to be put on antibiotics. When he was neutered, he died on the table, but was brought back to life. He is a sweet, fun-loving boy. Because Foster and Regal are a bonded pair, they must be adopted together.

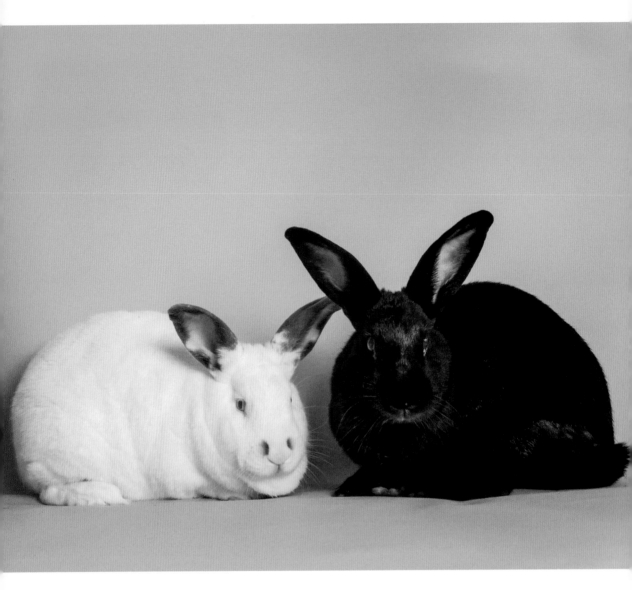

DC and Fifi

DC is bonded to his sister, Fifi, also known as "Fatty." These two best friends love to run around and chase each other. They are both affectionate, but Fifi doesn't want you to stop petting her. They lived with their dad until he became too sick to care for them. They were placed with a rescue and live together in a foster home.

Fenway and Fiona

Fenway and Fiona are a bonded pair of Lop-Eared rabbits. Fenway is a friendly, easygoing bunny. He was surrendered to a local animal shelter where he languished for seven months. Fortunately, this great rabbit was taken in by a rescue, and he now lives in a foster home with his partner, Fiona. Sadly, Fiona had a rough start; she was used in a lab for testing prior to ending up in a rescue, where she quickly bonded with Fenway.

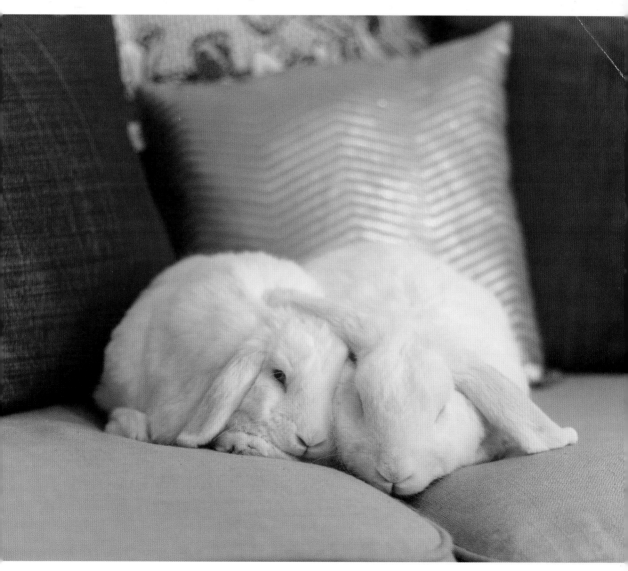

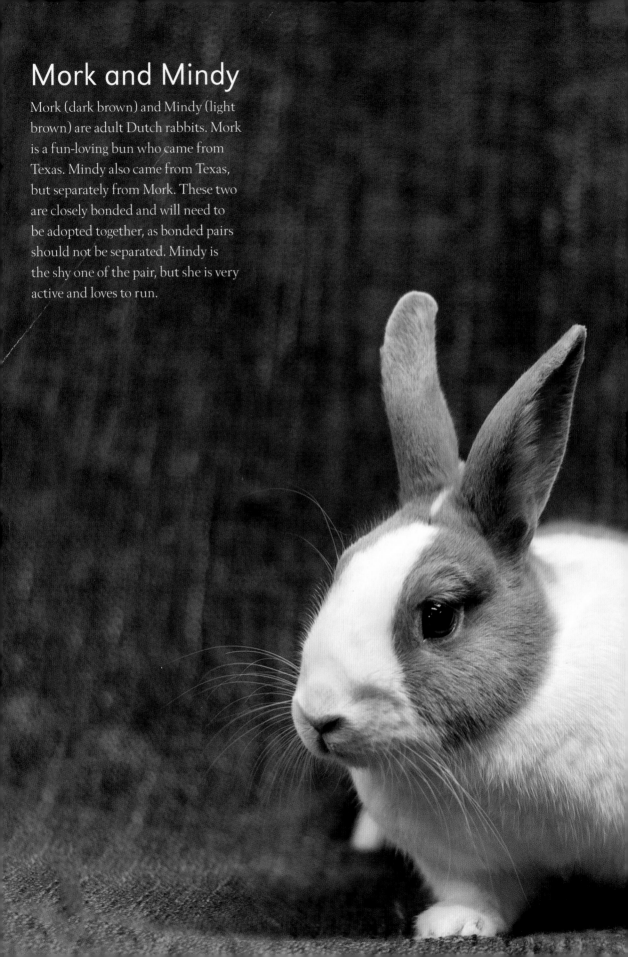

Mork and Mindy

Mork (dark brown) and Mindy (light
brown) are adult Dutch rabbits. Mork
is a fun-loving bun who came from
Texas. Mindy also came from Texas,
but separately from Mork. These two
are closely bonded and will need to
be adopted together, as bonded pairs
should not be separated. Mindy is
the shy one of the pair, but she is very
active and loves to run.

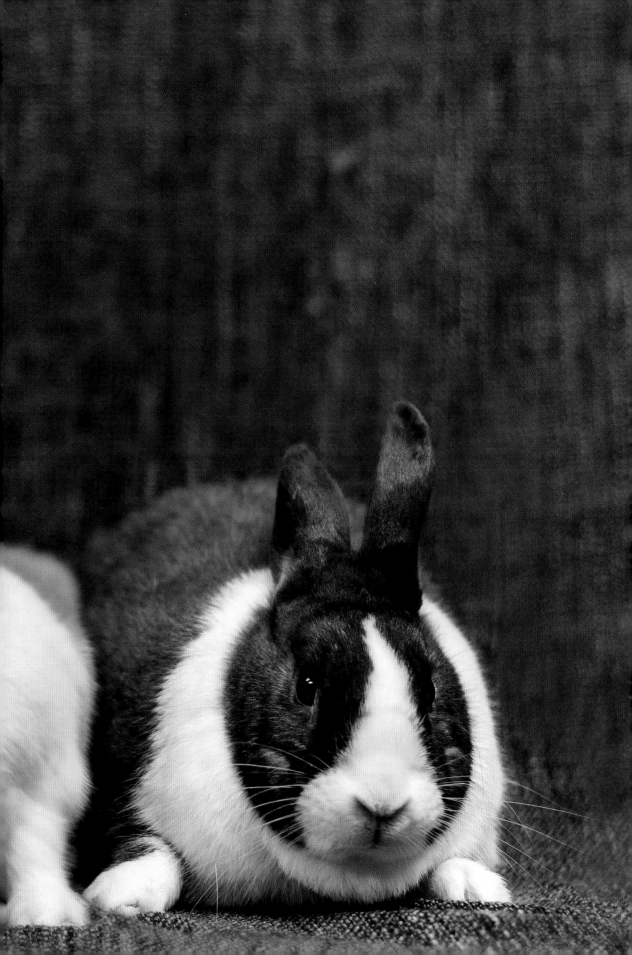

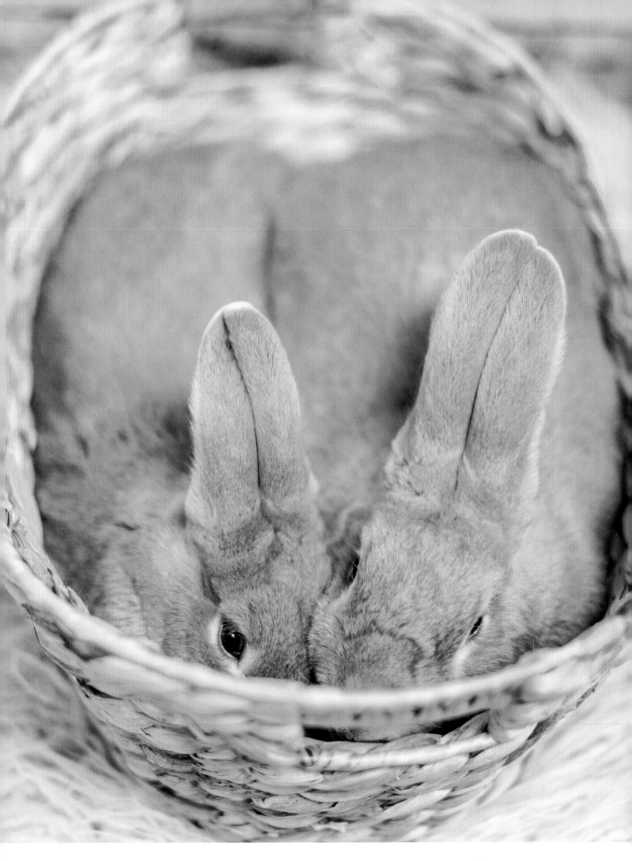

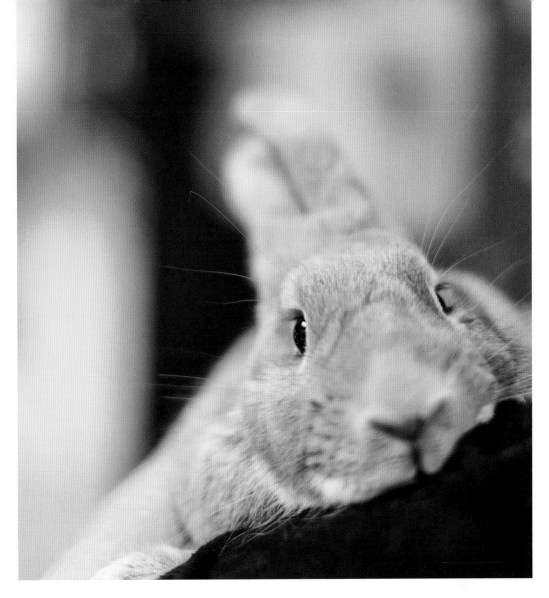

Sage and Tansy

(previous page and above) Sage was a breeder rabbit who was dumped outside, along with all the other rabbits, when the breeder was done with them. Sage and her daughter, Tansy *(above),* were the only ones to survive. Tansy is more outgoing than her mom; however, both Sage and Tansy are a little skittish due to their time in the wild. Tansy was born outdoors and attacked by a hawk, suffering a torn ear.

These girls will need a home with a lot of room, as they are large rabbits and like to have plenty of space to run around. They are a bonded pair and must be adopted together.

Stella and Louise

Stella is what is called a T-Rex bunny, because of a physical deformity in her front leg. She ended up in rescue when she was left at a vet's office. Though Stella's right front paw bends inward, that doesn't stop her from doing all the normal bunny things.

Louise ended up in rescue when she was found dumped in someone's yard in Fremont, Ohio.

These two bonded bunnies were adopted from the same rescue and are best friends who have great fun together.

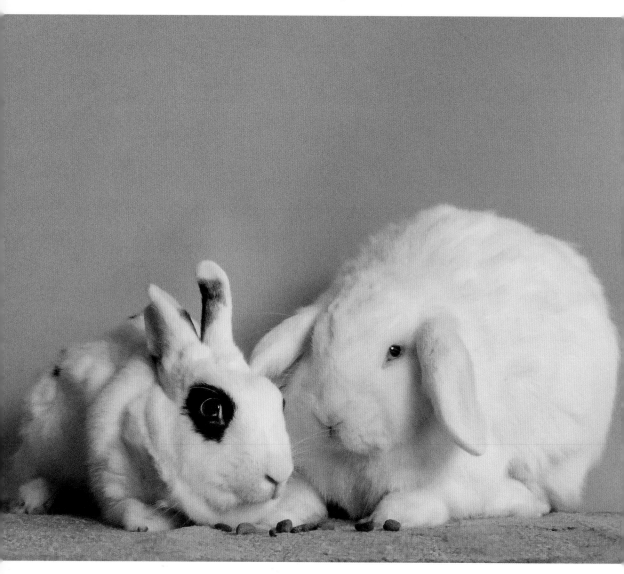

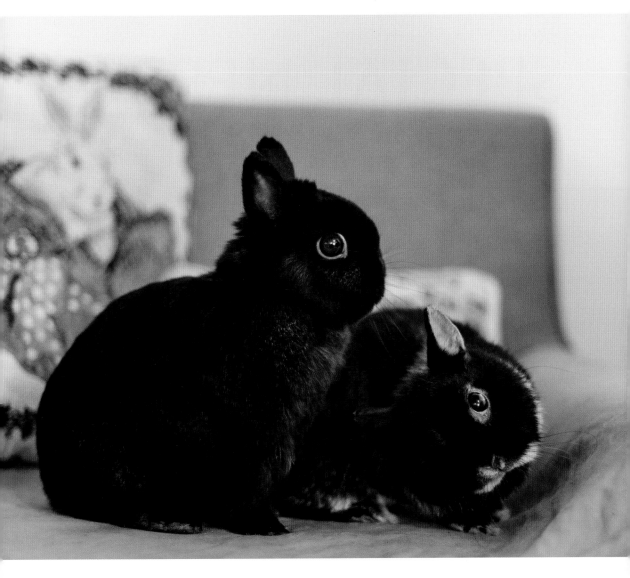

Miracle and Mickey

Miracle is the sweet Silver Marten Netherland Dwarf with a permanent head tilt. She is about two years old and came from a breeder who either gave or sold her to a homeless woman. Although the homeless woman loved her, she couldn't provide the care she needed. Miracle ended up with a rescue and was then adopted, but she was looking for a friend. So, Miracle's adopter discovered Mickey, who was available for adoption from a rescue in Elizabethtown, Kentucky. The two are now a happily bonded pair.

SPECIAL NEEDS

Scarlett O'Hare

Scarlett O'Hare is a small black Lop who used to live at a vocational school vet tech program in Cincinnati. As a result, she is looking for an experienced rabbit owner who will be patient with her and help build her confidence. She is a friendly girl, but extremely cautious. While she is desperate to trust someone, it's important to move slowly and talk softly to her; otherwise, she may box you with her front feet!

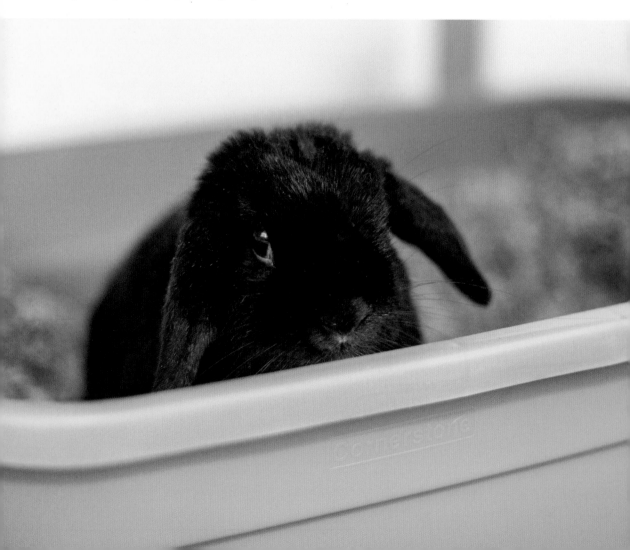

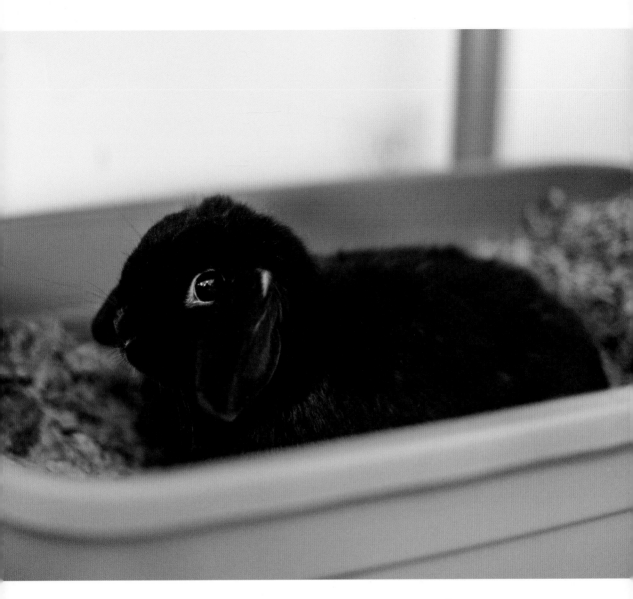

"Scarlett O'Hare is a small black Lop who used to live at a vocational school vet tech program in Cincinnati."

Belle

Belle is tiny, as she is a Netherland Dwarf, one of the smallest breeds of rabbit. She is around six years old and came to her rescue from the humane society. She is playful and can be protective of her toys. Belle is considered special needs because she requires approximately three visits per year to the vet due to some dental issues.

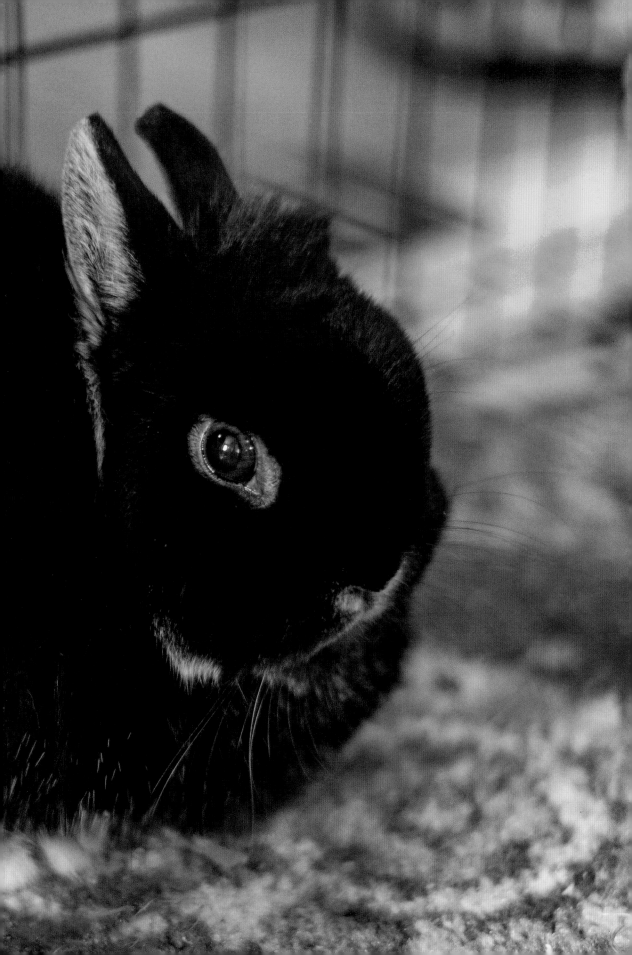

Bentley

Bentley was surrendered to rescue by
someone who grew tired of caring for him.
He requires special care because of his mega
colon condition. He is a sanctuary bunny
with his rescue and will live out his life in
his permanent foster home.

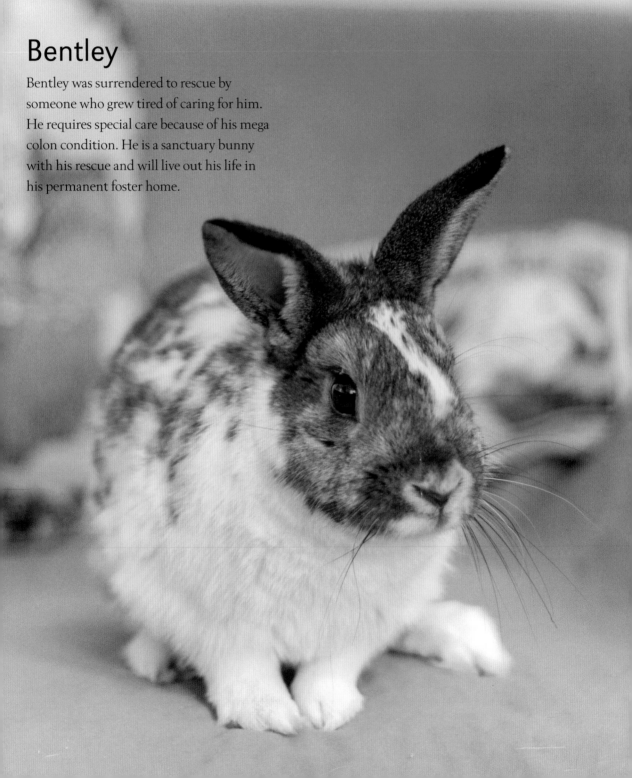

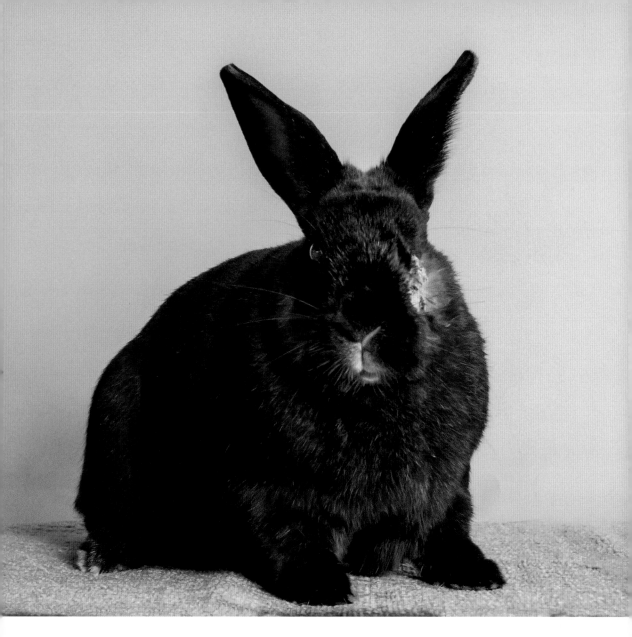

Nelly Belly

Nelly Belly is a seven-plus-year-old rabbit. She was found as a stray in Avon, Ohio, and taken in by a rescue and cared for in a foster home. She was supposed to be a temporary foster, but she jumped out of her pen and decided to hang out with the resident house rabbit, Humphrey. She had a few abscesses, and her eye was removed due to some blood pressure issues. Nelly Belly is very happy in her once temporary, now permanent, home.

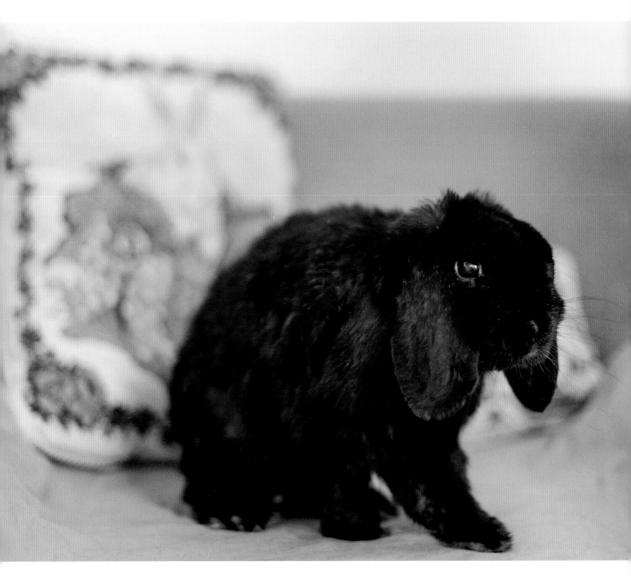

Rafiki

Rafiki, a very senior bunny thought to be over ten years old, was found in a box in front of a pet store on New Year's Eve, with no food or water. He hit the jackpot after that terrible event, coming to live in a loving adoptive home where his special needs as a senior bun were met, and he received the love and attention he craved. Sadly, Rafiki passed away a few months after his photo session.

Pepper

Pepper is a senior rabbit at over eleven years old. He spent
five months in a shelter in Downey, California, before being
flown to New York through the Bunderground Railroad
network of rabbit rescuers and transporters. From New York,
he ended up in Columbus, Ohio, before being adopted into
a home in Northern Kentucky. He showed signs of living a
rough life, looking a little beat up, especially on his left side.
He was also blind in his left eye. Unfortunately, Pepper's
health took a turn for the worse, and he passed away a few
months after this picture was taken.

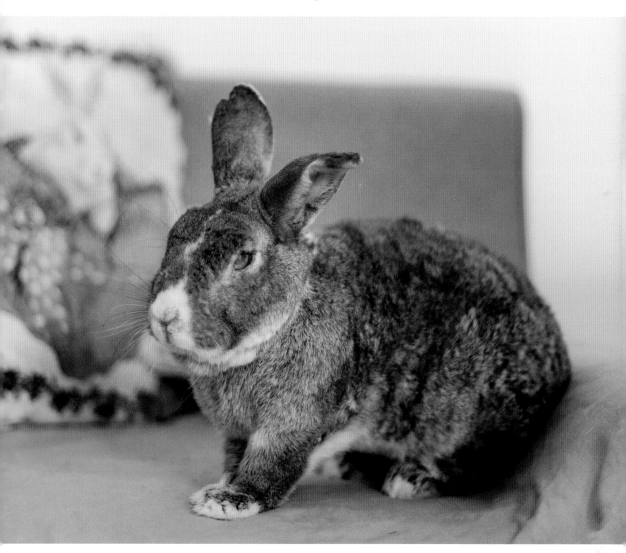

Claire

Claire was surrendered to a shelter by a breeder who no longer wanted her. She showed no signs of illness, but when the rescue took her to be spayed, the vet diagnosed her with uterine cancer. Though the vet removed as much of the cancer as possible, her foster family was told the cancer cells had spread outside of her uterus. Given no more than a year to live, Claire became a sanctuary bunny with her rescue; she would live out the rest of her life with her foster family. Claire surprised everyone and lived three years beyond her original diagnosis! The last few years of Claire's life were spent as a happy, beloved house rabbit—and she especially loved the family dogs.

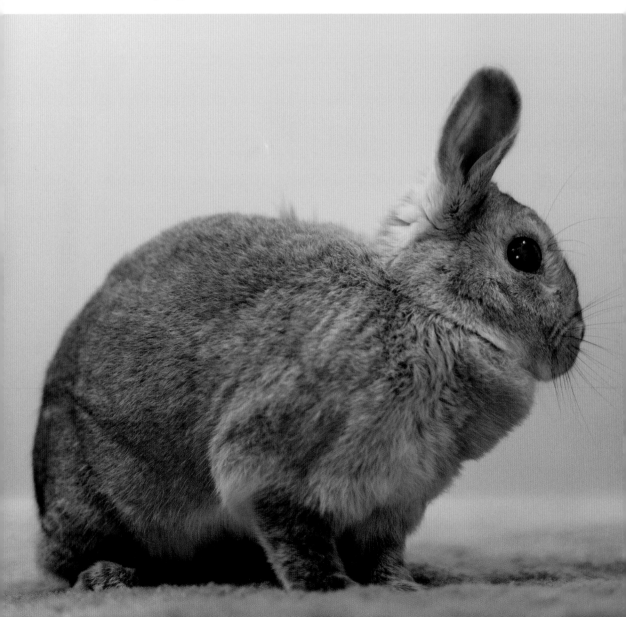

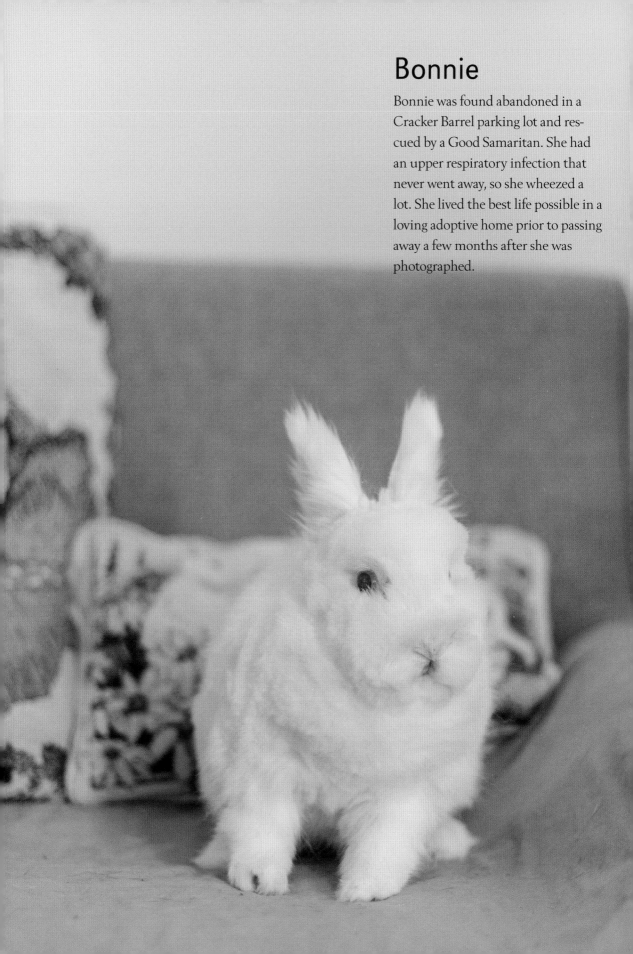

Bonnie

Bonnie was found abandoned in a
Cracker Barrel parking lot and res-
cued by a Good Samaritan. She had
an upper respiratory infection that
never went away, so she wheezed a
lot. She lived the best life possible in a
loving adoptive home prior to passing
away a few months after she was
photographed.

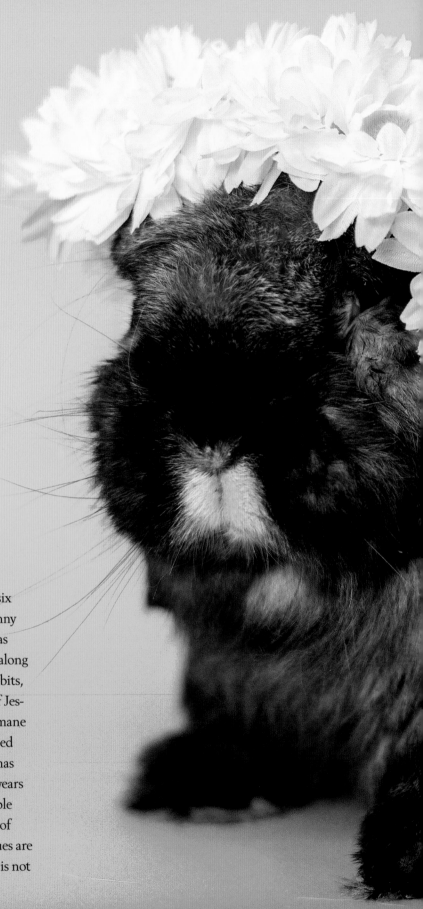

Jessica

Jessica is a senior rabbit at over six
years old. She is a sweet Lop bunny
who has had a rough life. She was
taken from a backyard breeder, along
with several other neglected rabbits,
by law enforcement. Custody of Jes-
sica was granted to the local humane
society, and from there, she ended
up with a rescue group. Jessica has
numerous health issues due to years
of neglect, but the rescue was able
to nurse her back to some form of
health. However, her health issues are
still significant enough that she is not
a candidate for adoption.

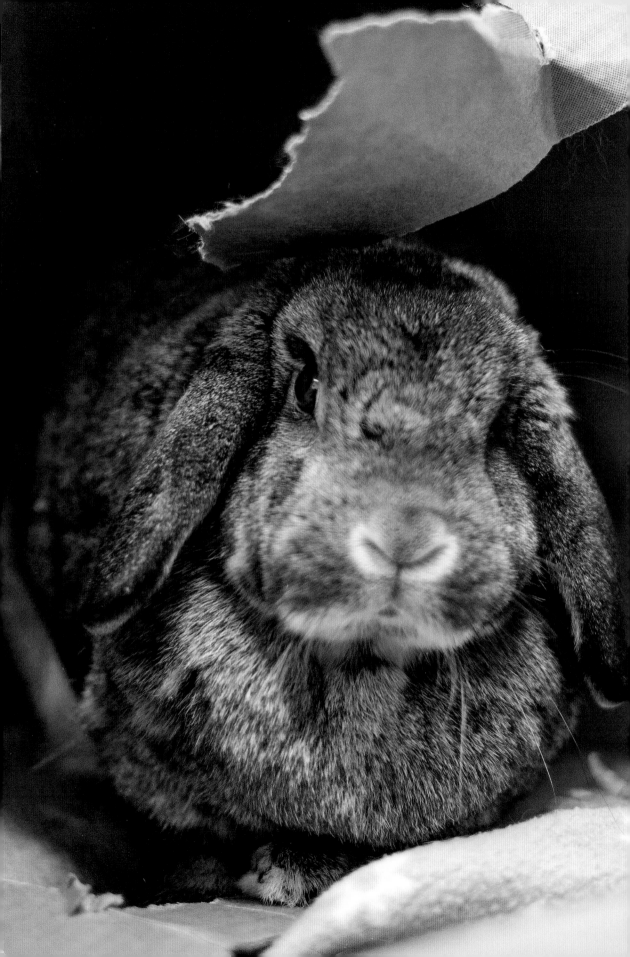

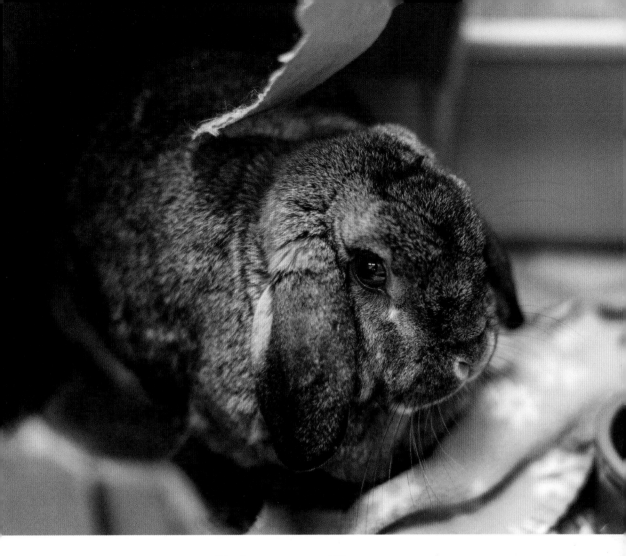

Princess Fiona

(*previous page and above*) Princess Fiona is a Lop-Eared rabbit who was brought into rescue in Northern Ohio from a shelter in Cincinnati. She is very skittish around humans and is expected to live out her life in a foster home, as it is hard to adopt out bunnies who are not people-friendly.

Martin

Martin was found abandoned in a cemetery with severely splayed hind legs and urine scald (which is caused when urine is left to soak on a rabbit's body, causing skin inflammation and hair loss). Despite his sad start, Martin is a friendly bunny who thrives on attention and especially loves when people scratch his inner ears, since he can't reach them with his legs. Because of Martin's condition, he requires extra care and attention—especially in making sure that he is kept clean.

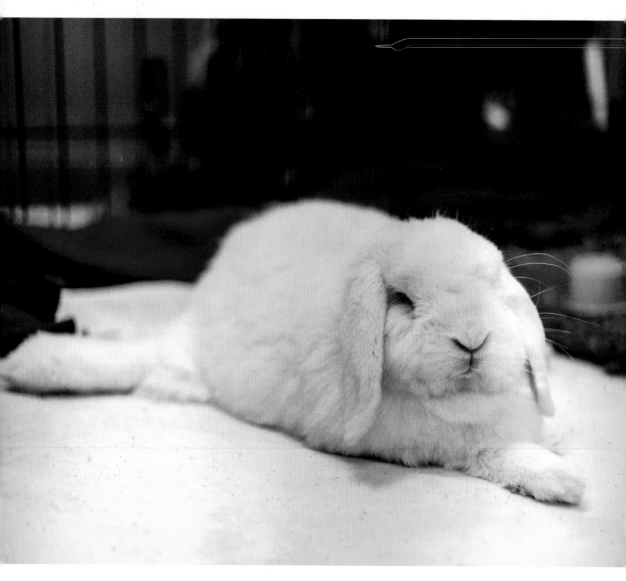

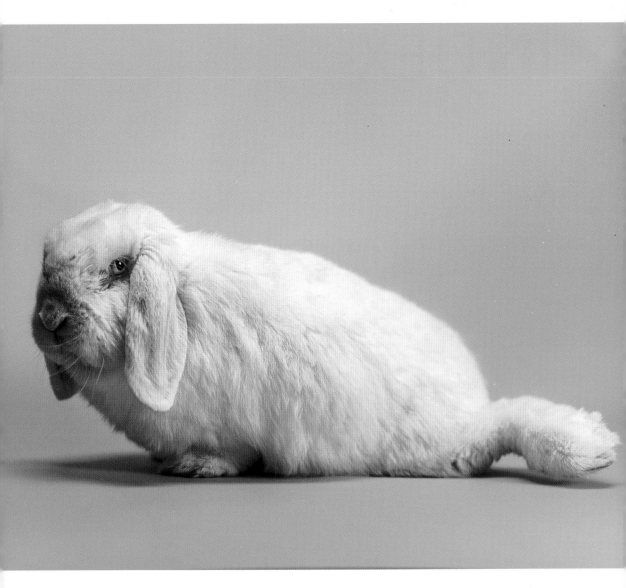

"MARTIN WAS FOUND ABANDONED IN A CEMETERY WITH SEVERELY SPLAYED HIND LEGS . . ."

INDEX

R

S

T

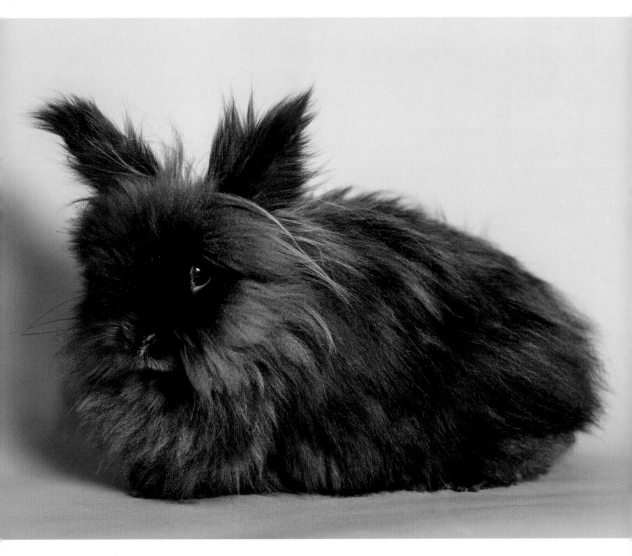

Dogs 500 POOCH PORTRAITS
TO BRIGHTEN YOUR DAY

Lighten your mood and boost your optimism with these sweet and silly images of beautiful dogs and adorable puppies. *$19.95 list, 7x10, 128p, 500 color images, index, order no. 2177.*

Kids
PHOTOS TO BRIGHTEN YOUR DAY

Tracy Sweeney captures the joy, moods, and relationships of childhood in this magical book. *$24.95 list, 7x10, 128p, 180 color images, index, order no. 2182.*

Owls in the Wild
A VISUAL ESSAY

Rob Palmer shares some of his favorite owl images, complete with interesting stories about these birds. *$24.95 list, 7x10, 128p, 180 color images, index, order no. 2178.*

The Frog Whisperer
PORTRAITS AND STORIES

Tom and Lisa Cuchara's book features fun and captivating frog portraits that will delight amphibian lovers. *$24.95 list, 7x10, 128p, 350 color images, index, order no. 2185.*

Polar Bears in the Wild
A VISUAL ESSAY OF AN ENDANGERED SPECIES

Joe and Mary Ann McDonald's polar bear images and Joe's stories of the bears' survival will educate and inspire. *$24.95 list, 7x10, 128p, 180 color images, index, order no. 2179.*

Fancy Rats
PORTRAITS & STORIES

Diane Özdamar shows you the sweet and snuggly side of rats—and stories that reveal their funny personalities. *$24.95 list, 7x10, 128p, 200 color images, index, order no. 2186.*

The Sun
IMAGES FROM SPACE

Travel to the center of our solar system and explore the awesome beauty of the star that fuels life on earth. *$24.95 list, 7x10, 128p, 180 color images, index, order no. 2180.*

Teardrop Traveler

Photographer Mandy Lea left her job for life on the road—and along the way, captured both life lessons and incredible images of America. *$24.95 list, 7x10, 128p, 200 color images, index, order no. 2187.*

Trees in Black & White

Follow acclaimed landscape photographer Tony Howell around the world in search of his favorite photo subject: beautiful trees of all shapes and sizes. *$24.95 list, 7x10, 128p, 180 images, index, order no. 2181.*

Street Photography

Andrew "Fundy" Funderburg travels the globe and shows you how documenting your world can be a rewarding pastime and an important social tool. *$24.95 list, 7x10, 128p, 280 images, index, order no. 2188.*

The Complete Guide to Bird Photography, 2ND ED.

Photographer Jeffrey Rich shows you the ins and outs of beautifully documenting birds in the wild. $24.95 list, 7x10, 128p, 280 images, index, order no. 2189.

National Parks

Take a visual tour through all 59 of America's National Parks, exploring the incredible histories, habitats, and creatures these lands preserve. $24.95 list, 7x10, 128p, 375 color images, index, order no. 2193.

Wild Animal Portraits

Acclaimed wildlife photographer Thorsten Milse takes you on a world tour, sharing his favorite shots and the stories behind them. $24.95 list, 7x10, 128p, 200 color images, index, order no. 2190.

The Moon
NASA IMAGES FROM SPACE

Take a trip to our nearest neighbor in the night sky and explore the alluring beauty and scientific wonder of the moon. $24.95 list, 7x10, 128p, 200 color images, index, order no. 2194.

Raptors in the Wild

Rob Palmer shares his breathtaking images of hawks, eagles, falcons, and more—along with information on species and behaviors. $24.95 list, 7x10, 128p, 200 color images, index, order no. 2191.

Penguins in the Wild
A VISUAL ESSAY

Joe McDonald's incredible images and stories take you inside the lives of these beloved animals. $24.95 list, 7x10, 128p, 200 color images, index, order no. 2195.

First Moments
NEWBORN PORTRAITS & MOM STORIES

Brooke VanHoy shares beautiful images and heartwarming stories that parents and grandparents will love. $24.95 list, 7x10, 128p, 200 color images, index, order no. 2192.

Cats 500 PURR-FECT PORTRAITS
TO BRIGHTEN YOUR DAY

Lighten your mood and boost your optimism with these sweet and fiesty images of beautiful cats and adorable kitten.$24.95 list, 7x10, 128p, 200 color images, index, order no. 2197.

Underwater Photography

Take an underwater journey with Larry Gates as he explores a hidden world and reveals the secrets behind some of his favorite photographs created there. $37.95 list, 7x10, 128p, 220 color images, index, order no. 2116.

Storm Chaser
A VISUAL TOUR OF SEVERE WEATHER

Photographer David Mayhew takes you on a breathtaking, up-close tour of extreme weather events. $24.95 list, 7x10, 128p, 180 color images, index, order no. 2160.